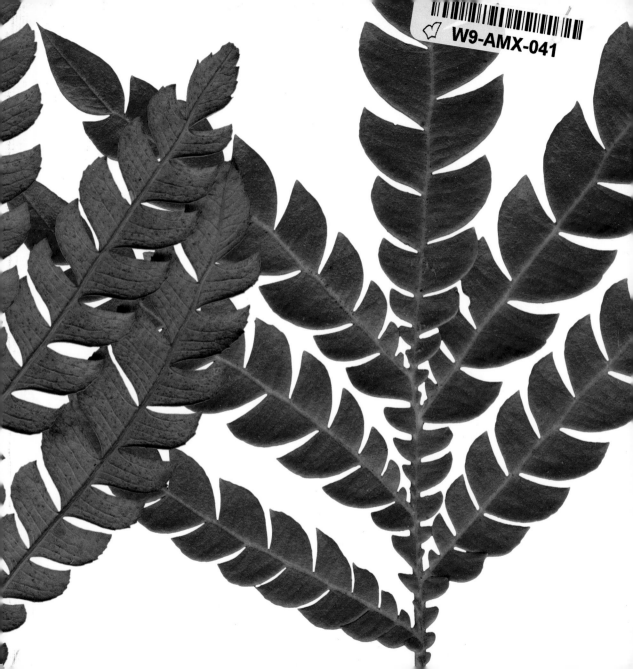

leaves & pods

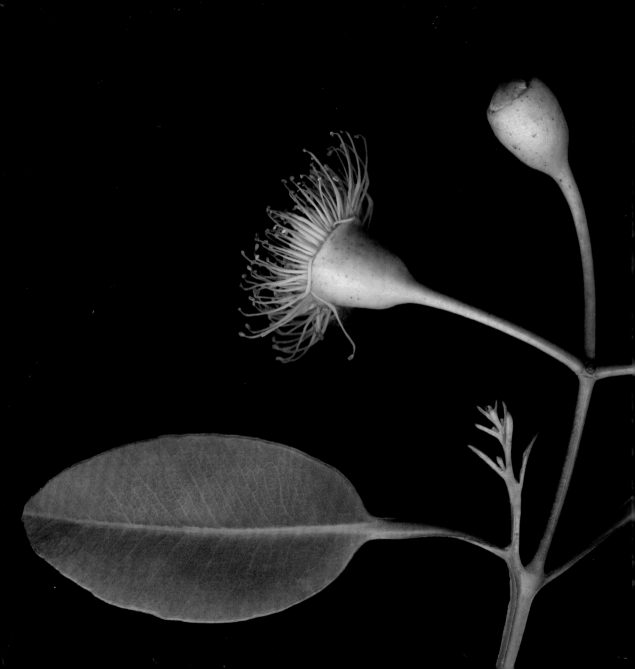

leaves & pods

photographs by Josie Iselin | *text by* Mary Ellen Hannibal

abrams, *new york*

Editor: Nancy E. Cohen
Designer: Darilyn Lowe Carnes with E. Y. Lee
Production Manager: Jane Searle

Library of Congress Cataloging-in-Publication Data

Iselin, Josie.
 Leaves & pods / photographs by Josie Iselin ; Text by Mary Ellen Hannibal.
 p. cm.
 ISBN 10: 0–8109–3078–1 (hardcover)
 ISBN 13: 978–0–8109–3078–0
 1. Photography of leaves. 2. Iselin, Josie. 3. Leaves—Pictorial works.
I. Title: Leaves and pods. II. Hannibal, Mary Ellen. III. Title.

 TR726.L42I84 2006
 779'.34092—dc22
 2006003158

Printed and bound in Singapore
10 9 8 7 6 5 4 3 2 1

HNA
harry n. abrams, inc.
a subsidiary of La Martinière Groupe
115 West 18th Street
New York, NY 10011
www.hnabooks.com

For my seedpods, Eliza, Deedee, and Andrew | JLI

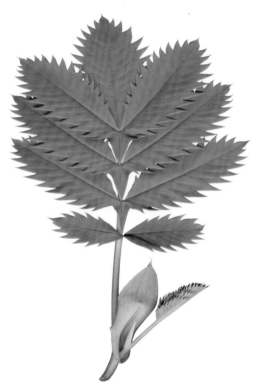

And for mine, Eva and Nick | MEH

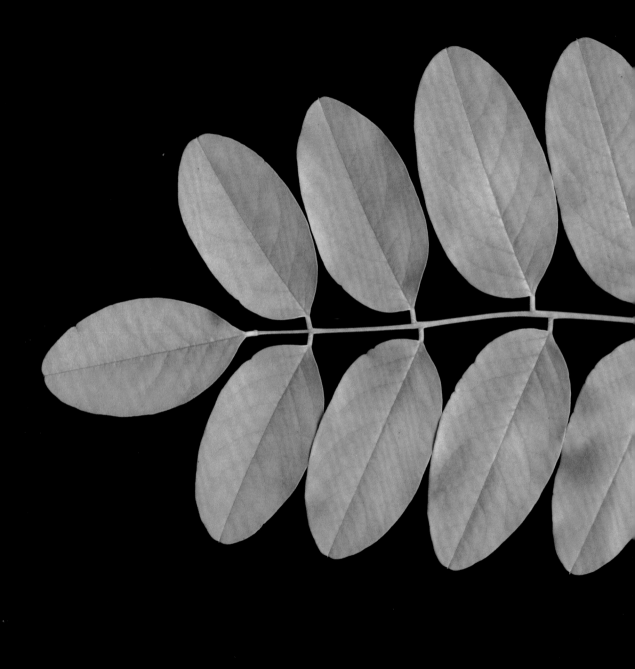

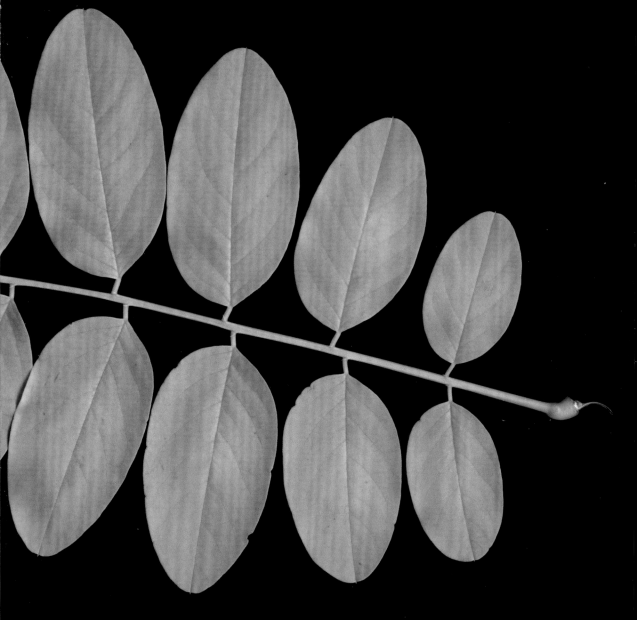

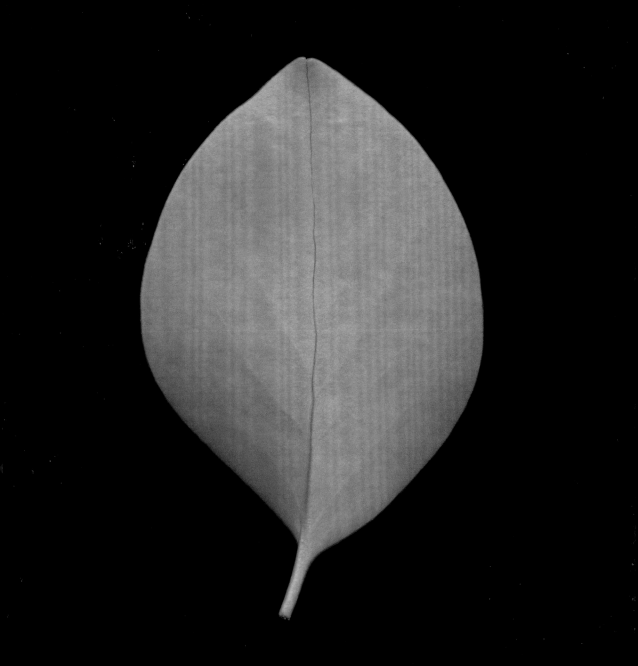

introduction

Gazing up from the base of a healthy maple tree into its green, sun-stippled canopy is to contemplate tens of thousands of variations on a single theme, every leaf the same, yet subtly different. A stroll from that tree to any other reveals the incredible diversity of leaves, each species displaying its own distinct type. The array expands across the seasons, from the delicate new growth that emerges in springtime to jewel-toned fall foliage to winter's brown husks. And as they unfurl, mature, and poignantly wither, leaves evoke the cycle of our own lives.

But leaves are more than a metaphor for existence; they are its underpinning. All the nuances of shape, size, color, and texture that make leaves so pleasing to the eye also aid the leaf in its ultimate purpose, which is no less than to sustain life on earth.

Through photosynthesis, leaves convert sunlight to the energy and oxygen that in the end support every living thing. The green-pigmented chlorophyll in their cells absorbs light, metabolizing it with the help of carbon dioxide and water drawn from the atmosphere through stomata, pores on the leaves' underside. The chemical reaction produces the sugars that nourish the plant and generate fruits, nuts, and legumes for the rest of the food chain. It

also yields oxygen and water, which the stomata release, or transpire, giving us the air we breathe and the moisture that becomes clouds and, eventually, rain.

Leaves are so vital to life it is no wonder that virtually every culture through the ages has venerated some tree. The oak, for example, has been held sacred by people in almost every land where it has grown, including ancient Hebrews and druids. Greeks, Norse, and Slavs all associated it with their thunder god. The oak's hard wood and long life made it a symbol of strength and longevity. Endowed with numinous meaning, many trees are similarly woven into our lore, literature, and religion.

Each aspect of a leaf's appearance has meaning too, helping a given leaf photosynthesize efficiently under given environmental conditions. Most leaves are green, thin, and flat, shaped to expose as many of their cells as possible to the light and the atmosphere. The broader its surface, the more light the leaf can capture; the thinner it is, the more easily it can transport water, sugars, and carbon dioxide. It stands to reason that leaves in low light are larger, thinner, and darker green (that is, more laden with chlorophyll) than leaves exposed to bright sun. As the detailed portraits in this book make clear, a close look at any leaf reveals its particular adaptations not only to light but also to temperature, available water, and predators.

Leaves' seemingly infinite multiplicity springs from a limited set of features. Trees are grouped into two types: conifers and broadleafs. Conifers

are usually evergreen, with leaves that are needlelike or scaly and with cones to contain their seeds, rather than flowers and fruit. Broadleaf trees can be evergreen or deciduous, shedding leaves seasonally; they have flat leaves and reproduce by flowering. Their leaves may be simple (in one piece, lobed like a maple leaf or unlobed like a birch) or compound (divided into leaflets). They may attach to the stem singly, in pairs, or in whorls, with three or more leaves at the node. Broadleaves come in ten basic shapes, with seven varieties of leaf tip and eight bases. The leaf edge, or margin, can be smooth, saw-toothed, scalloped, wavy, or curled under.

To make order of the diversity, botanists have for more than three hundred years classified trees by broad physical similarities. However, DNA analysis is now upending those categories—and our understanding of trees. Each year hundreds of species are being reclassified according to their genetic structure: The maple will henceforth belong to the same family as the lychee, while the elm turns out to be closely related to nettles.

Although the sumptuous photographs collected here demonstrate patterns that may link or distinguish species, this book does not delve into botanical classifications and is not an identification guide. It is, rather, an exploration of the beauty, wonder, and purpose of some of the most familiar and most important objects in the natural world.

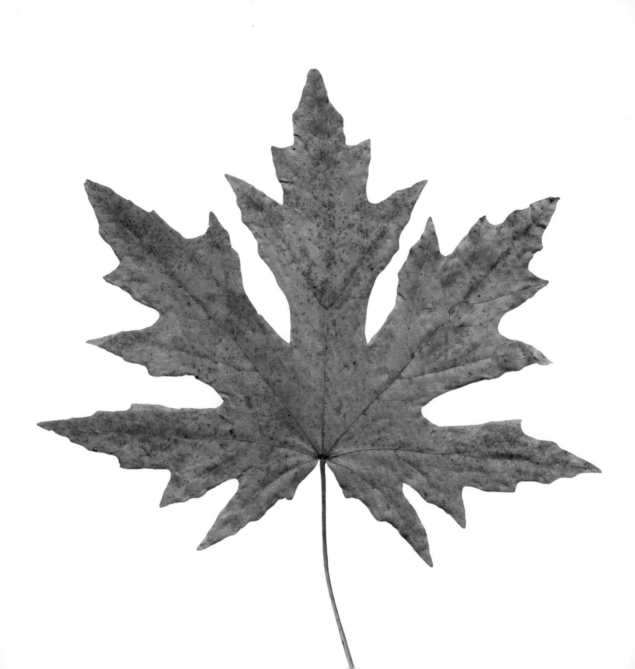

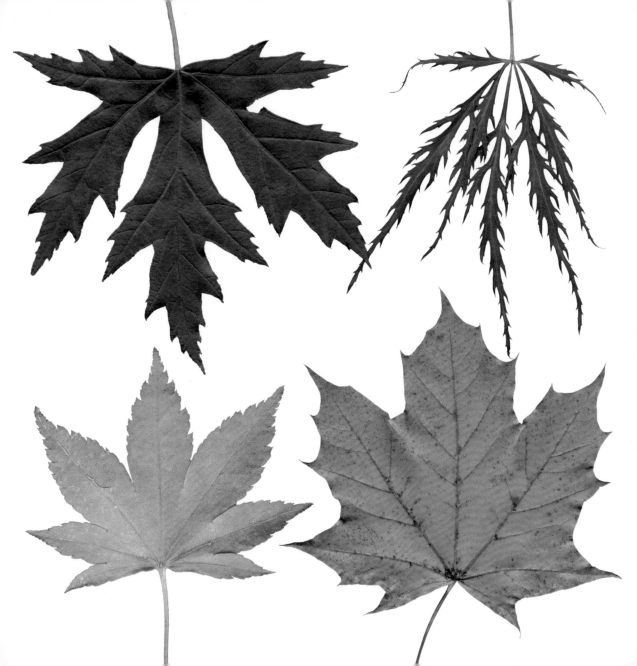

Preceding pages, clockwise from left: **Bigleaf maple**, **silver maple**, **dissected Japanese maple**, **Norway maple**, **Japanese maple**. *Opposite:* **Japanese maple spray**. The maple is rivaled only by the oak along the tree-lined streets of America's small towns. There are 120 species, with disparate leaf shapes adapted to conditions of climate, soil, and spacing—whether the tree grows free in an open plain or with many others in a dense forest. With incredible diversity built into their genes, trees in a given family can call on whichever features are needed for survival. For example, the deep clefts in the feathery dissected Japanese maple may have developed to ward off a particular insect by making it difficult to land on or travel over the leaf. One characteristic all maples share is their leaves' palmate pattern, in which the lobes and veins extend from a single point, like fingers from a palm.

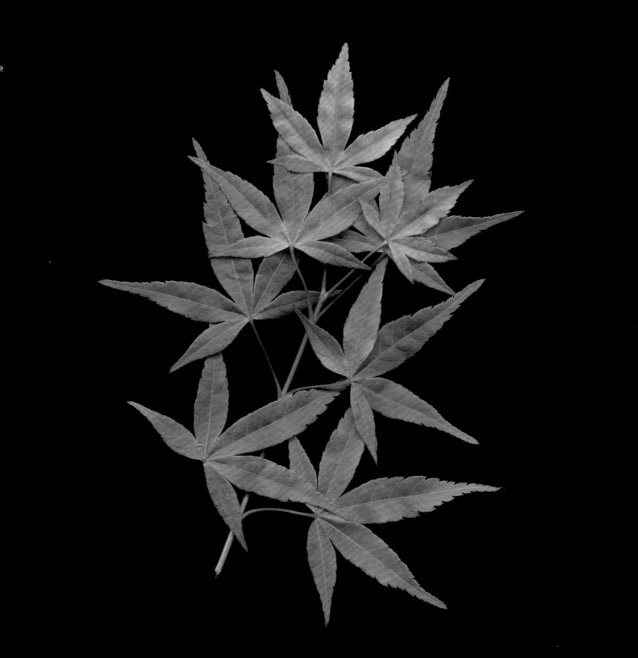

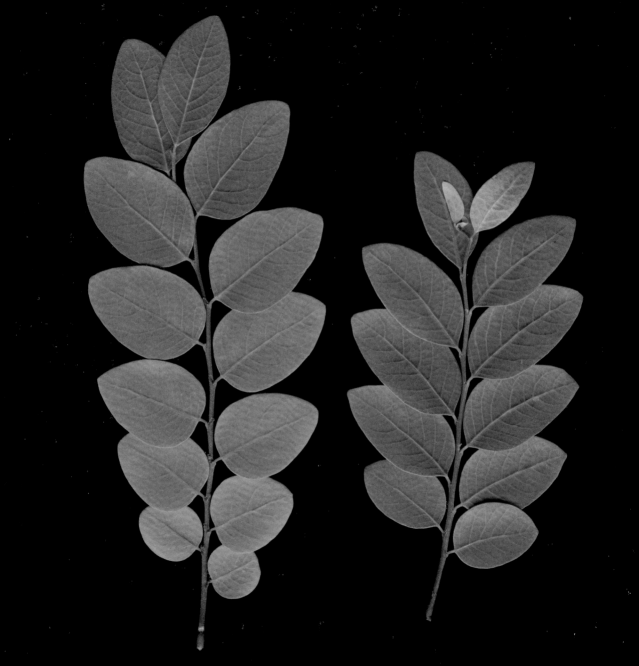

Opposite and following pages: **Phyllanthus flexuosus.** Where the maple leaf is palmate in shape, the *Phyllanthus flexuosus* is pinnate, or feathery, with its leaflets attached on either side of the stem in an orderly alternating pattern. Jockeying for position in the light, leaves fit together like a jigsaw puzzle to form what is called the leaf mosaic.

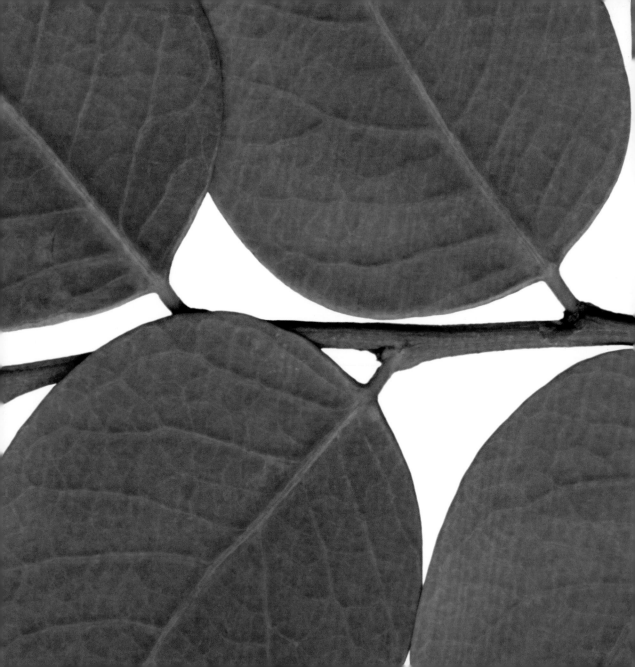

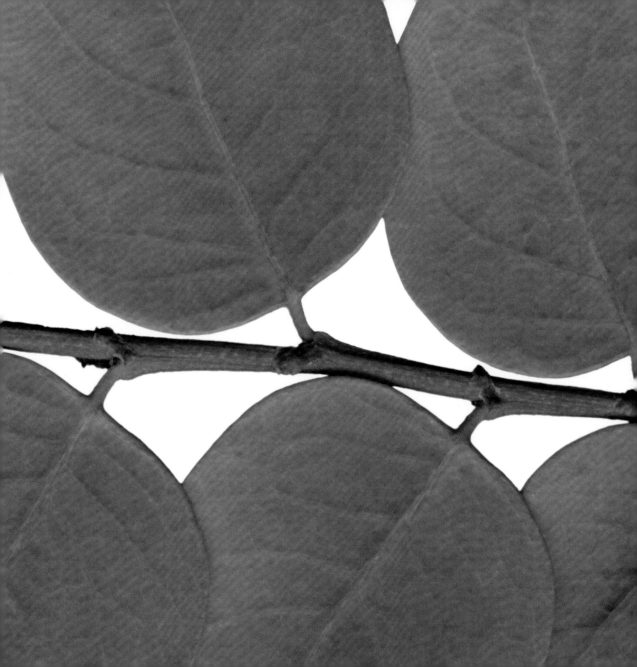

Sumac. Like the *Phyllanthus flexuosus*, the sumac has compound leaves, divided into leaflets. Trees more commonly have simple—that is, undivided—leaves. Compound leaflets either alternate on the stem, as seen on the *Phyllanthus*, or are joined in opposite pairs, as on the sumac. Variations in leaf shape and attachment regulate the leaf's exposure to sun and carbon dioxide and its ability to move freely in the wind.

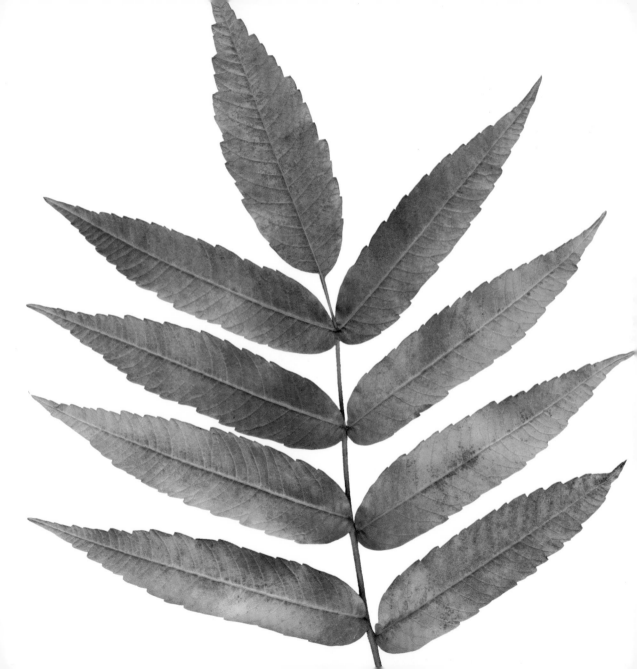

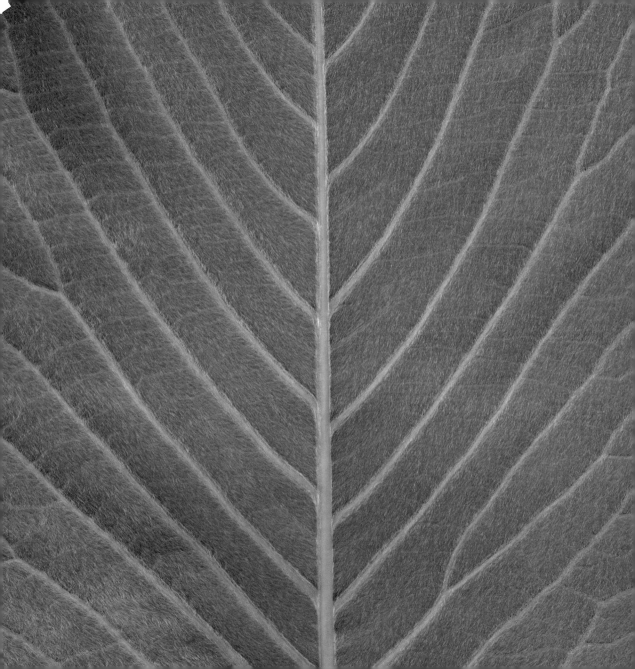

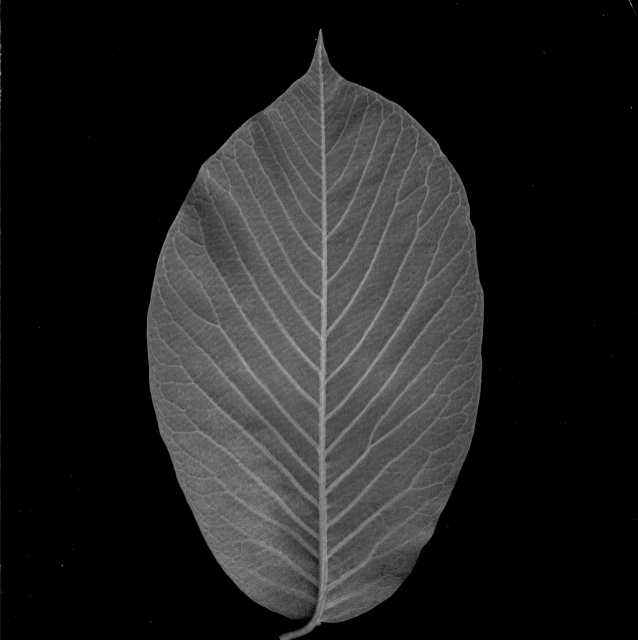

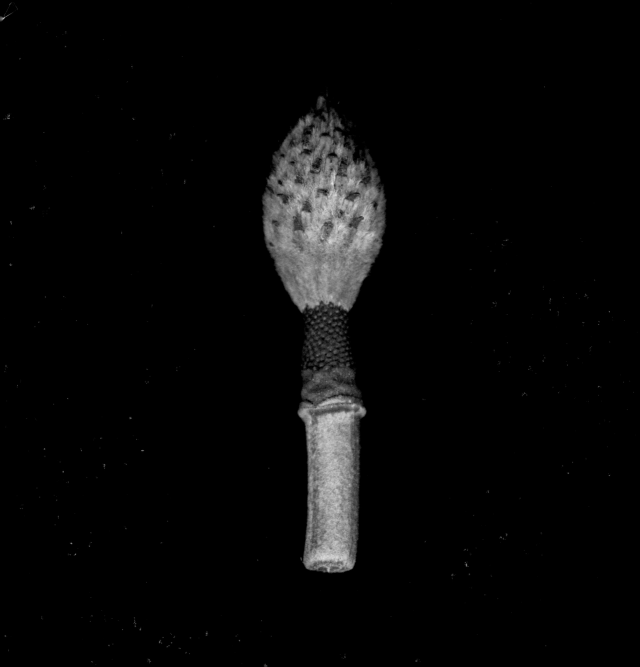

Preceding pages: **Magnolia leaves.** *Opposite:* **Magnolia seedpod.** A native of warm climates, the magnolia is designed to avoid dehydration. An emphatic tracery of veins carries water throughout the leaves, which have an especially dense layer of cutin, the waxy coating (or cuticle) all plants have, to protect against scorching and water loss. Tropical plants have thick cuticles for the opposite reason: to help shed the abundant precipitation that would overwhelm the leaves' ability to transpire excess water and cause them to rot. Magnolias, one of earth's most primitive angiosperms, or flowering trees, predate butterflies and bees; they have been pollinated by beetles since their emergence millions of years ago. Magnolia flowers, which bloom as large as ten inches across, ripen into huge, paintbrushlike seedpods. At maturity, each scale will split open, dropping a magenta magnolia seed on a pink string.

25

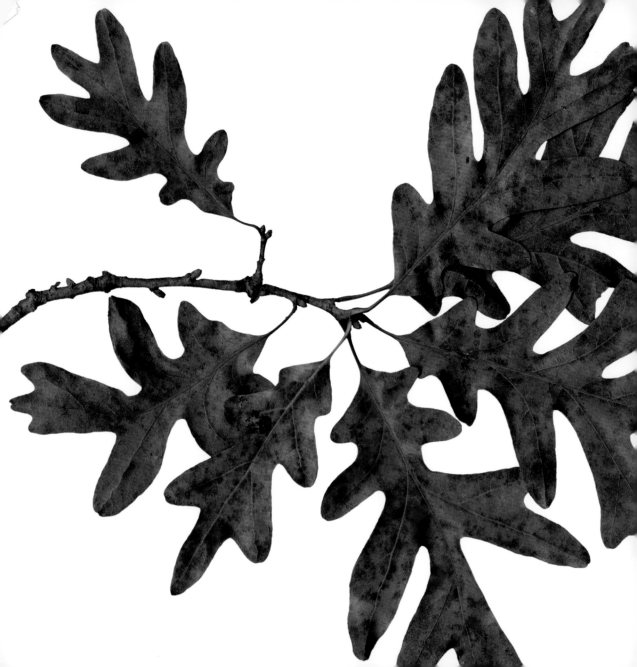

Opposite: **White oak.** *Following pages:* **Pin oaks.** The more space in and around leaves, the better the wind can circulate and provide the carbon dioxide each leaf needs for photosynthesis. The deep, curvy lobes of these oak leaves also prevent the leaf from tearing in the wind and allow sunlight to filter down to other leaves. Different as the various oak leaves may be (compare these lobed leaves to the small unlobed coast live oak on pages 70–71), you can always tell an oak by its acorn. No other tree has a nut or seed encased by a cap. The acorn nourished ancient peoples and is an important source of food for woodland creatures.

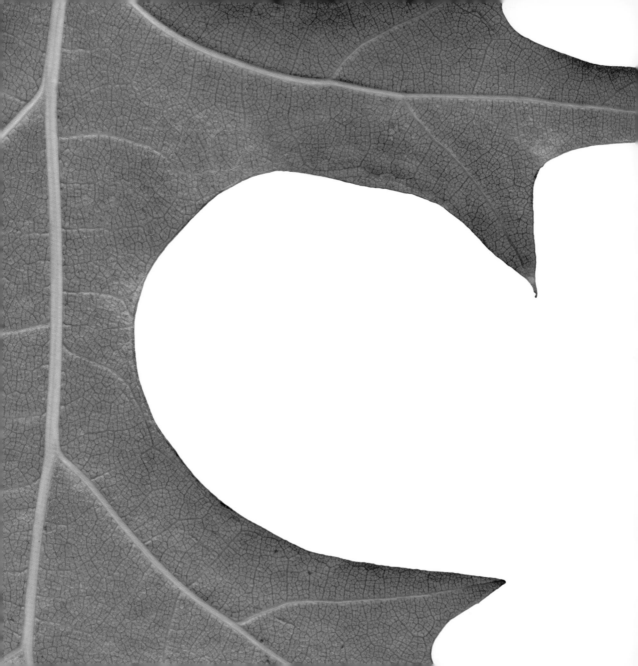

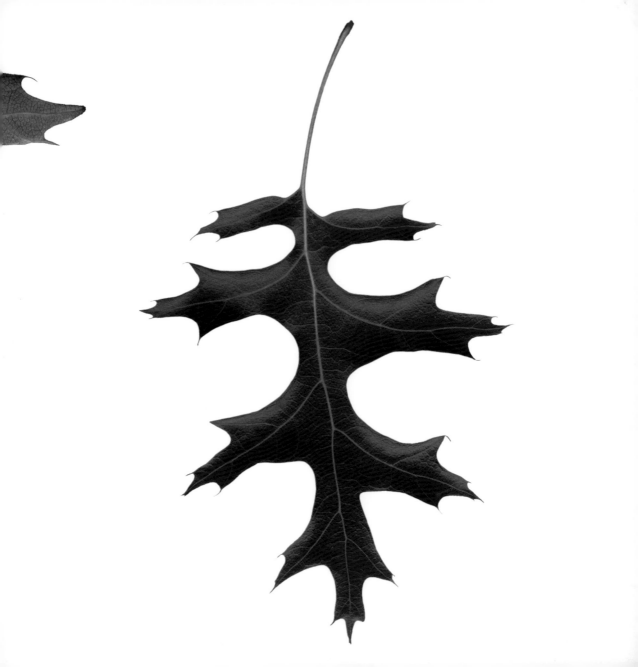

Eastern white cedar. This evergreen seems to be ironed flat, but each small scale of the fanlike spray is a fully functioning leaf that breathes and makes chlorophyll. When rubbed, the leaf releases an aromatic resin that may trigger memories of mothproof closets and backyard decks, often made with the tree's remarkable wood. The tree is resistant to decay and can live for centuries. Native Americans used its wood to build canoes and boiled the bark into a tea high in vitamin C to deter scurvy. After it saved some of his subjects from the disease, Francis I of France gave the tree a new name: *arbor vitae,* tree of life.

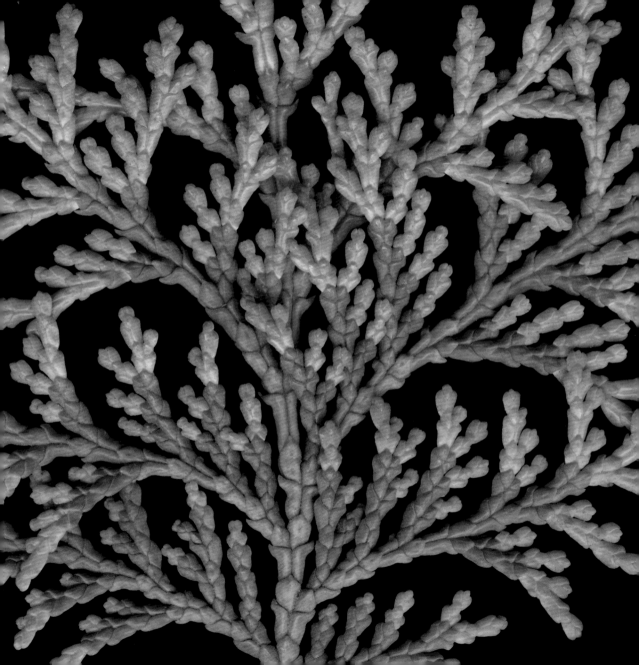

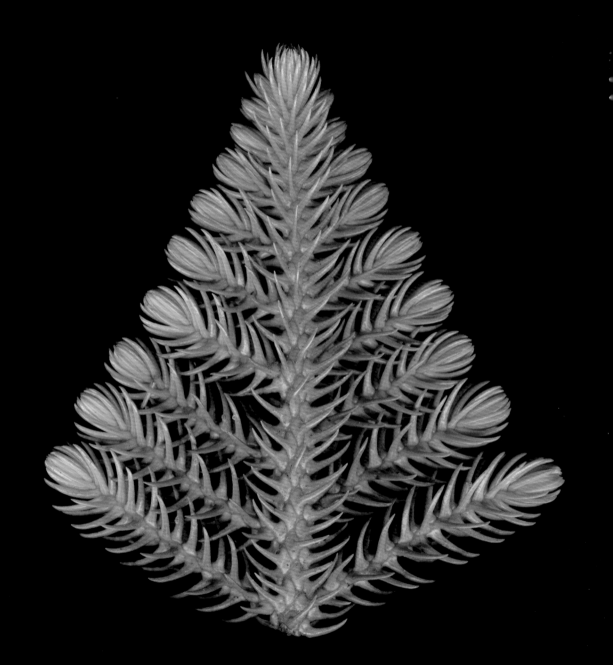

Norfolk Island pine. This evergreen, native to a tiny island east of Australia, is not a pine at all but part of a different, small family of conifers that includes the bunya-bunya and monkey puzzle trees. The conical tree has branches whorled around the trunk in equally spaced horizontal layers; each layer has the same number of radiating branches; and the branches in each layer are of the same length. Whorled leaves thoroughly cover each branch just as the branches whorl around the trunk. The extraordinary symmetry makes any small sample resemble a perfect Christmas tree in miniature.

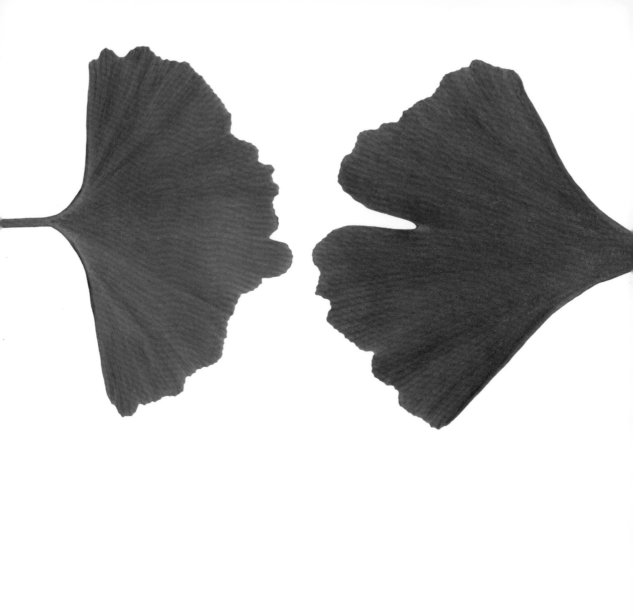

Ginkgo biloba. The ginkgo is a deciduous conifer, the sole survivor of a group of plants more primitive than conifers today. A symbol of longevity, today's ginkgo is virtually identical to ginkgos in the fossil record dating back two hundred million years. It has outlived virtually all its predators, and its hardiness makes the male of the species a popular tree for urban streets. The females produce fruit-covered seeds that give off a foul odor when the fruit falls and decomposes. (Ginkgo is Chinese for "silver apricot"; the second part of the name derives from the leaves' two lobes.) At one time the odor—the work of butyric acid—likely attracted some animal to eat the fruit and thus help disperse the seeds. Today it discourages the planting of the female tree.

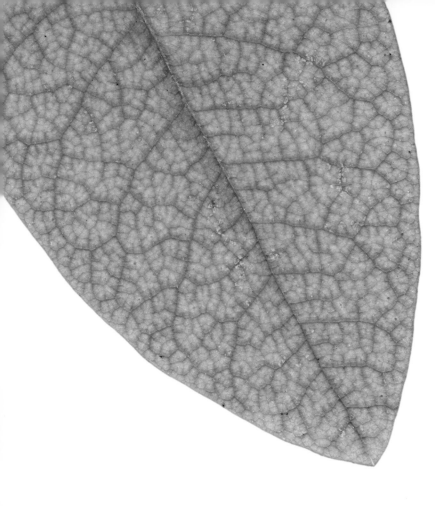

Opposite: **Rhododendron.** *Below:* **Birch.** The veins of a leaf are equivalent to a skeleton, with the main vein or midrib functioning as a spine, and numerous smaller veins branching and sub-branching from it. But plant veins also work as animal veins do, carrying vital fluids—in a leaf's case, water and dissolved sugars—to the main body. No cell of the leaf is more than two cells away from a vein or one of its sub-branches, the better to remain hydrated. Because the veins are denser than the fabric around it, chlorophyll lasts longer there, tracing the skeleton, as seen in the birch leaf here.

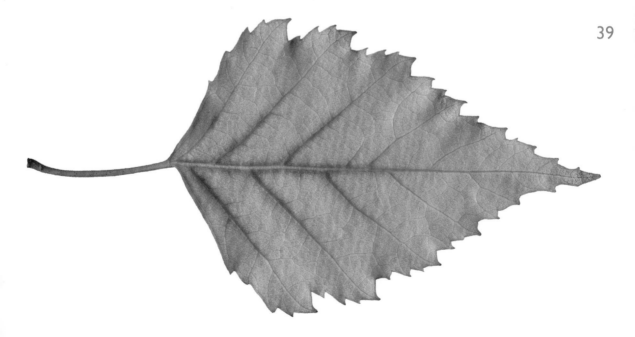

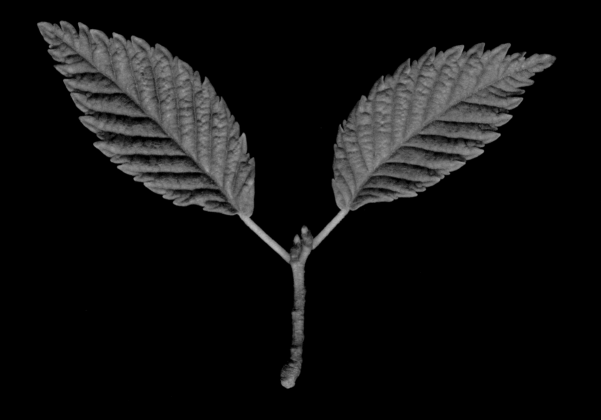

Opposite and following pages: **Elm.** The real "nightmare on Elm Street" was the Dutch elm disease that ravaged ninety percent of America's native elm species over the last century. Hybrids with resistant Japanese and Chinese strains have somewhat restored this icon, a towering shade tree favored by landscape architects, painters, and poets. The leaves have double sawtooth edges and are asymmetrical at the base. Some have hair on the top surface, but all are hairy on the underside. Most leaves are covered with hair or special glands to protect them from insects and dehydration; the hairs create a boundary layer and trap moisture.

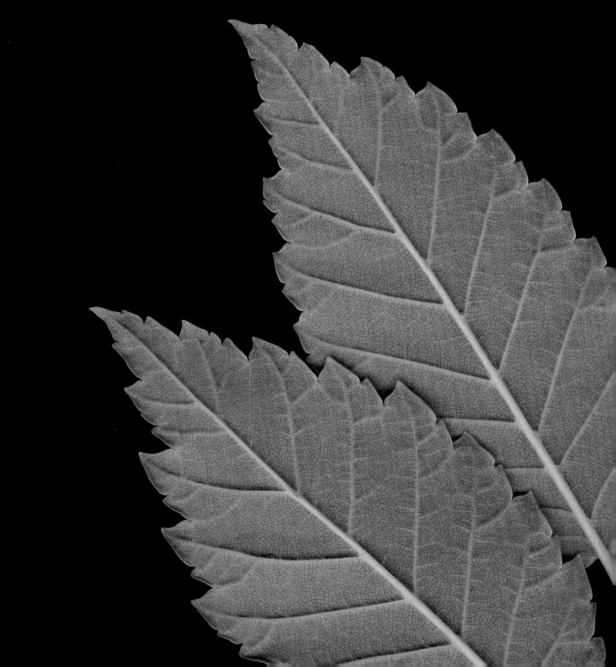

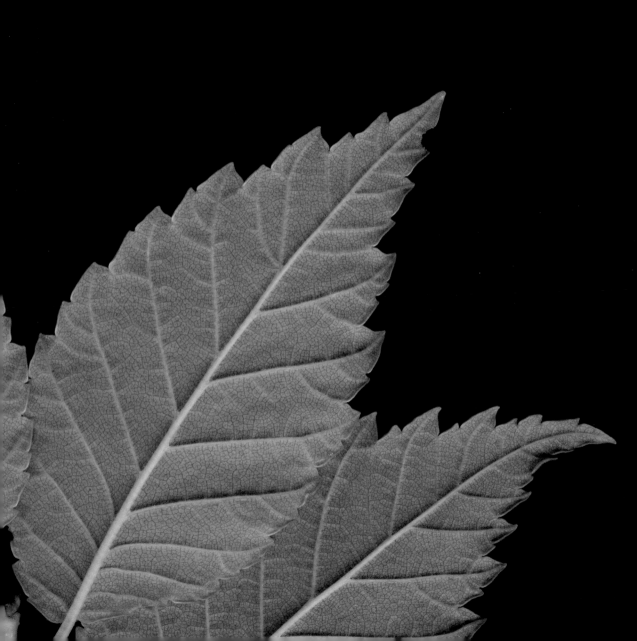

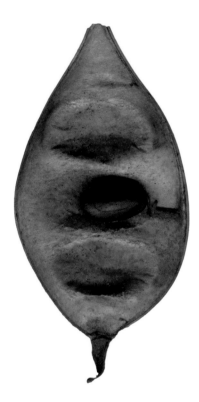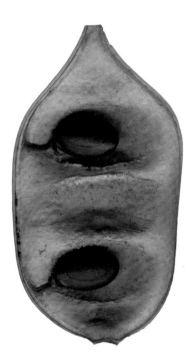

Acacia pod. Pods act as protective envelopes for the seeds cradled inside and are one of the ways trees bear their offspring. Other kinds of seed casings include berries and fleshy fruit (casings that are often edible) and hard nutshells (inedible casings for seeds that often are). Within this pod lie three potential acacia trees in their entirety.

Scots pine. These needles look more like grass than the leaves they are. Needles and scales, like the white cedar's, are leaves that have compacted to adapt to harsh, dry conditions. In pines they come in bundles of two, three, or five. A single vein courses through each needle, encased in chlorophyll-laden tissue that is itself enclosed by a thick epidermis and a waxy cuticle that prevents water loss.

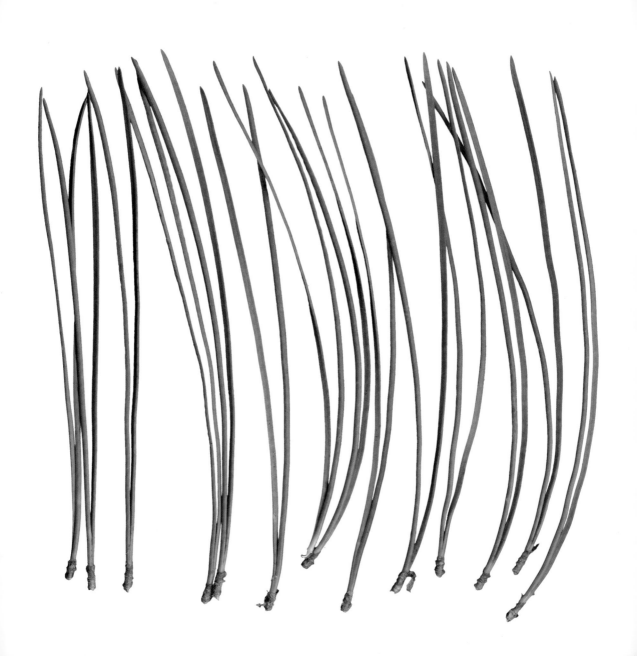

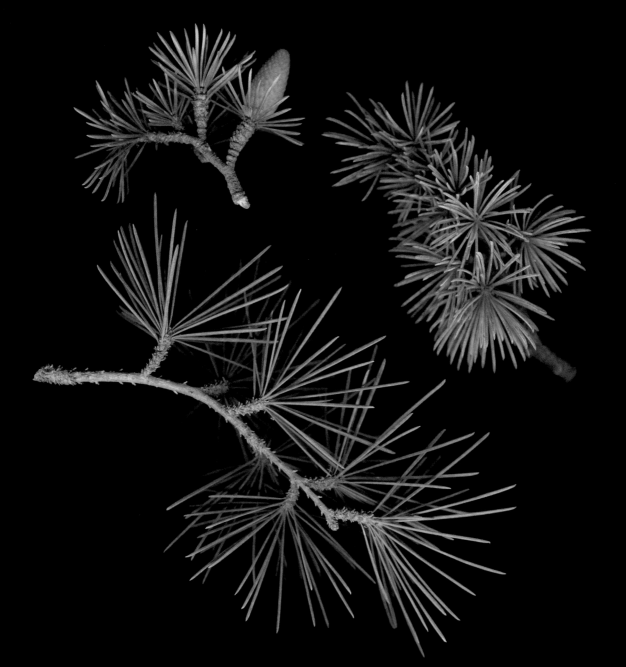

Clockwise from top left: **Cyprus cedar, atlas cedar, deodar cedar**. *Following pages:* **Cooper's pine.** A tree of the northern hemisphere, the pine has approximately 115 species, with needles that may be soft or spiky, round or flat, and of varying lengths, according to soil and climate conditions. Pine boughs may look pretty when laden with snow, but their needles need exposure to carbon dioxide and sunlight to function, so they are shaped to shed that frosty coat. Likewise, the needles on pines in Mesoamerican cloud forests, which have to contend with hundreds of inches of rain each year, point downward, helping the water flow off. But the needles on native California pines generally shoot upward, toward the sun.

49

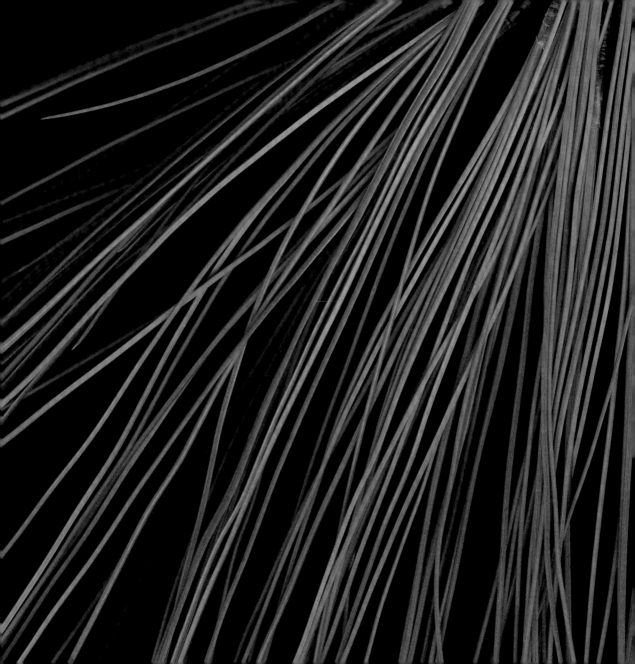

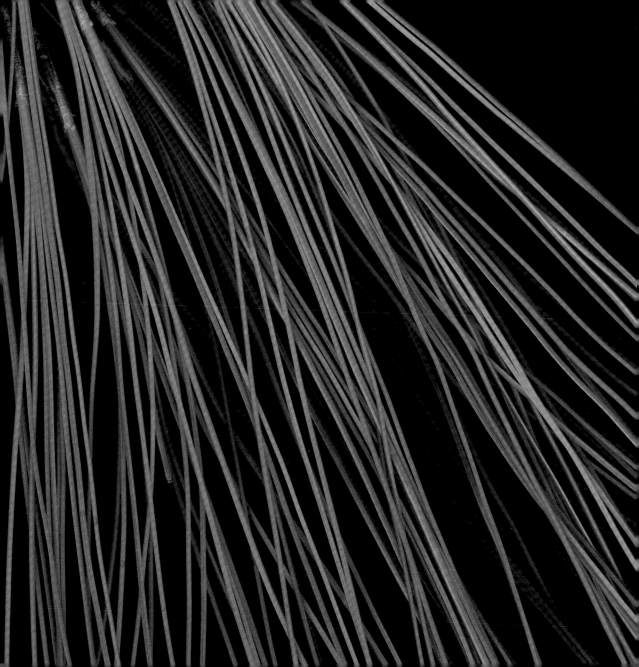

Sitka spruce. Legend has it that when Saint Boniface smote an oak being worshipped by pagans, a spruce grew in its place. The event initiated the conversion of the Germanic people to Christianity and the spruce's elevation as the Christian tree par excellence. In what might be seen as a little pagan revenge on Saint Boniface, the spruce has become the centerpiece of Christmas celebrations; its needles' radial symmetry helps hold ornaments particularly well. Stiff and sharp-pointed, spruce needles have no petiole, or stem, but grow directly from the twig in a spiral pattern.

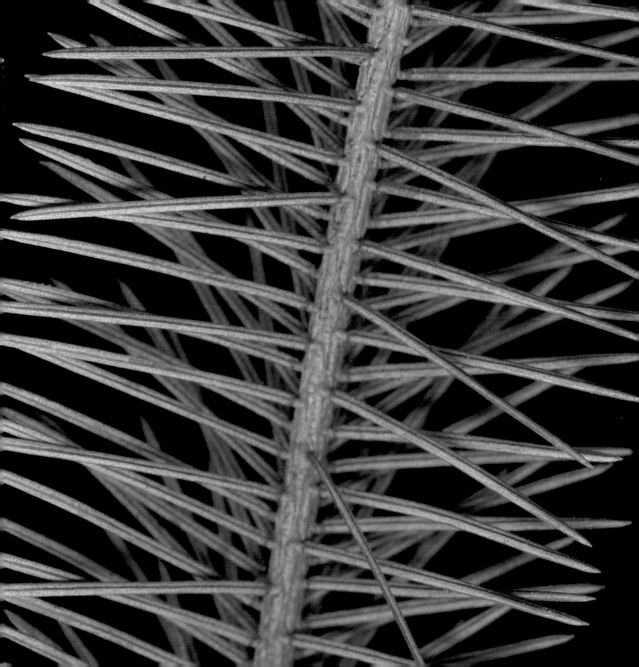

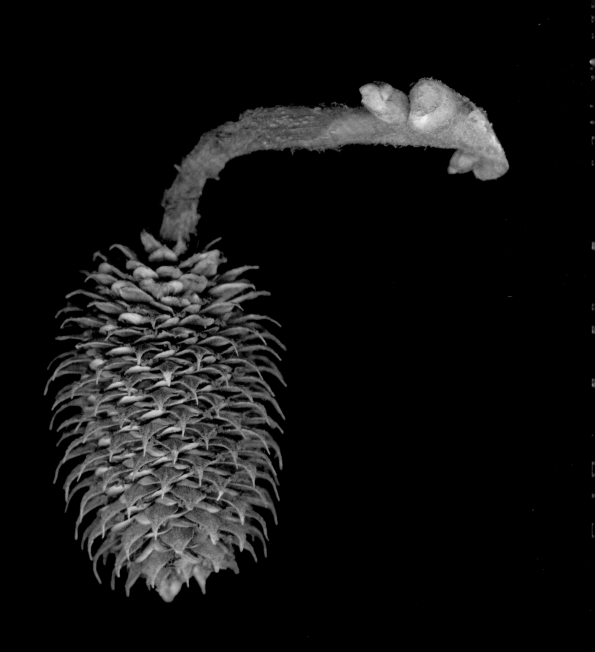

Opposite: **Catkin.** *Below:* **Spruce cone.** A cone is the fruit, or seed container, of most conifers, which belong to a plant group called gymnosperms (literally "naked seeds"). The scales of a cone are each part of an uncovered seed that is fertilized by pollen that travels through the air; they are brown and woody when ripe. Gymnosperms are considered less evolved than angiosperms, broadleaf trees that reproduce by flowering and generating seeds that are enclosed in an ovary, or ripened fruit, like a berry, nut, or legume.

55

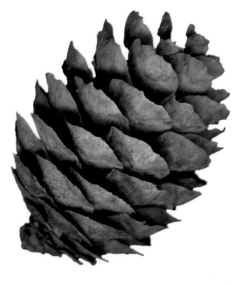

European yew. Evergreen canopies are formed with leaves of different ages, as the leaves live from two to four years and do not fall at one time. Younger leaves are often lighter in color because they aren't fully vested with chlorophyll until they've expanded and toughened and, as mature leaves, can protect and process the fragile green material. The light-colored lines on the underside of needles are stomata, the pores through which they breathe. The European yew, or *Taxus baccata*, is poisonous, but its leaves and bark are the source of taxol, the original source of the cancer-fighting drug tamoxifen.

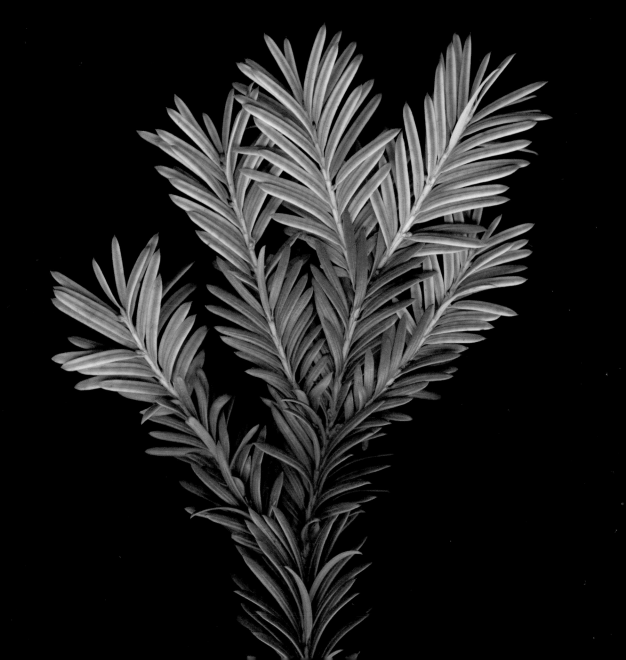

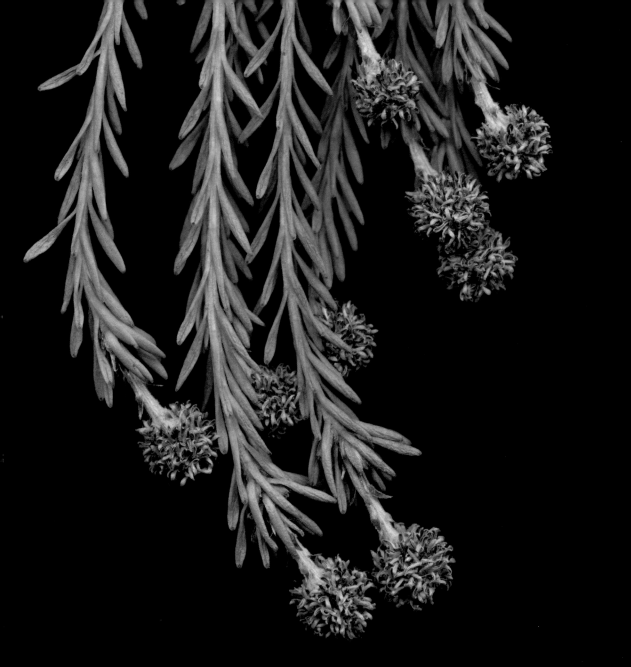

Opposite: **Cypress.** *Above:* **Coast redwood.** Also known as sequoia, the coast redwood is the world's tallest tree; the tallest known specimen, in Humboldt County, California, measures 369.5 feet. The coast redwood is ancient in every sense: Individual trees can live for two thousand years, and the fossil record dates the species back sixty-five million years, to the Cretaceous period. The flowerlike growths on the tips of the cypress's evergreen shoots are made up of soft scales, each holding two ovules inside. When the ovules are pollinated, they begin developing into seeds, and the scales close up around them in protection, turning into cones, a maturation process that may take two years.

Maple seeds. Known to many children as "twirlies," winged seeds' official name is samara. The diaphanous wings help the nascent trees flutter far and wide on the wind. Maple, ash, and elm trees all scatter their seeds in variously shaped samaras: The papery wing may be elongated, extending from one end of the seed, or disklike, surrounding a seed at its center.

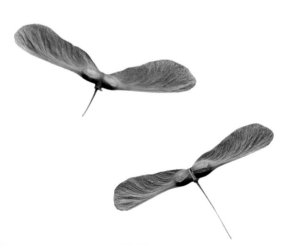

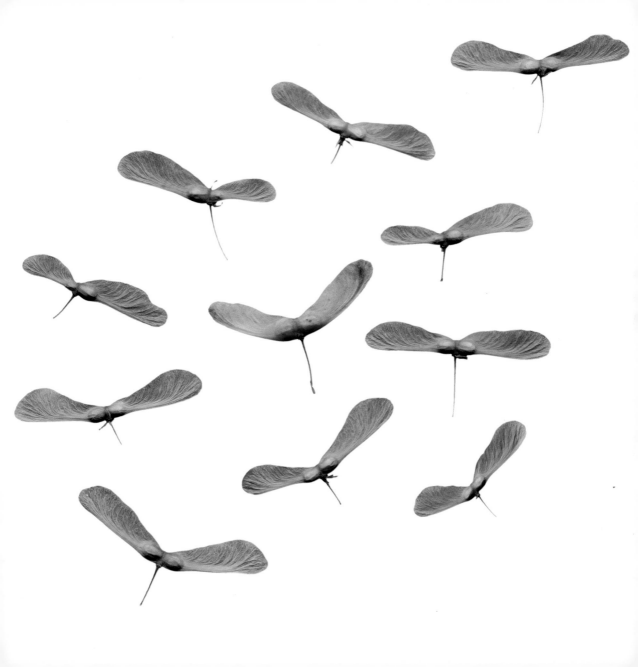

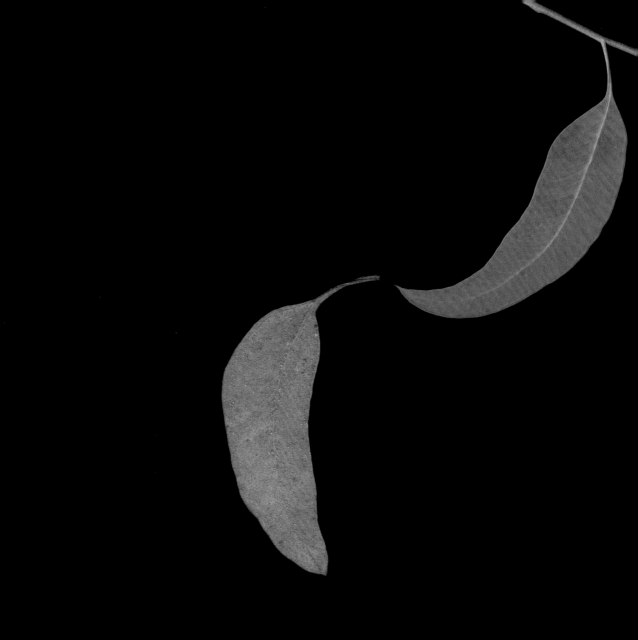

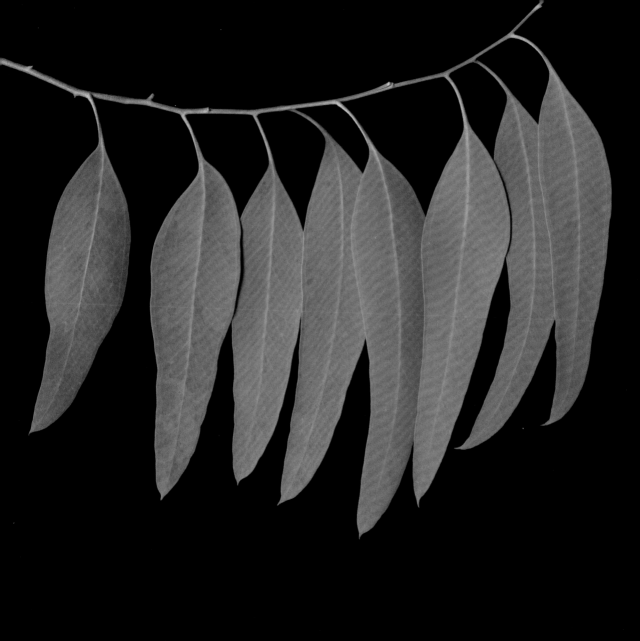

Preceding pages and opposite: **Eucalyptus.** Adapted to hot, dry climates, eucalyptus leaves hang vertically, with only their margins directed at the sun. Most leaves—even the needles of a conifer—move with the light, both to capture the sunshine and to protect against scorching. Agitating the air also helps them absorb more carbon dioxide. The clean, medicinal odor of eucalyptus is a result of transpiration: When the leaves release oxygen, traces of their powerful oil enter the air. The pungent oil deters many herbivores, but not the koala, which eats only eucalyptus leaves.

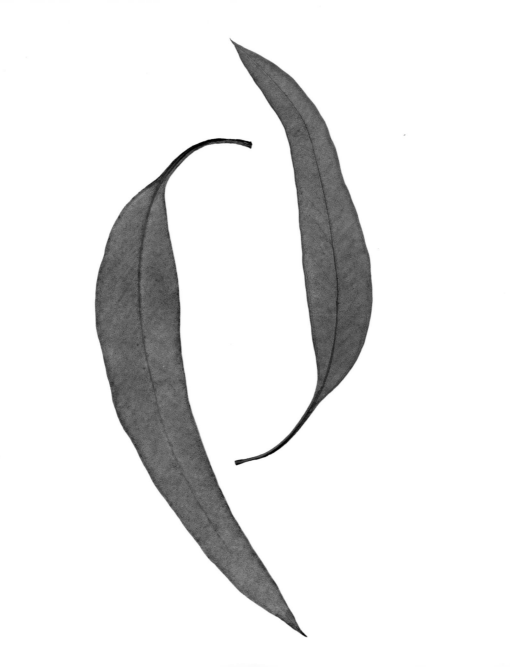

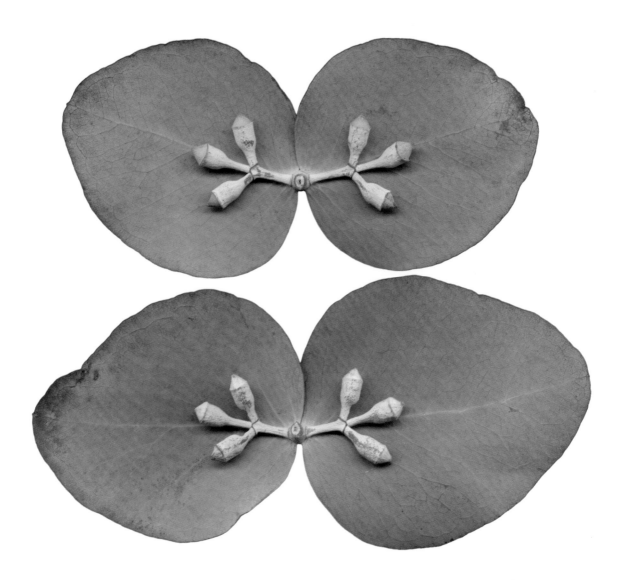

Eucalyptus. There are more than five hundred species of eucalyptus. The round-leafed eucalyptus that is commonly sold by the bunch or used in flower arrangements may come from one of the several species that have such leaves. Or it might be a juvenile of almost any species: Most eucalyptus trees produce rounded leaves when they are young and longer leaves (like those on page 65) as they mature. The little scepters seen here are the blue-green tree's fruit.

Ficus. The ficus withstands low humidity thanks to the thick layer of cutin on its shiny, pointed leaves and so makes an excellent houseplant. Indoors or out, its green leaves turn color only after they fall. Ficus, which can reach heights of one hundred feet in subtropical climates, are just as often shrubs as trees, a designation that has less to do with species than with size. A tree is defined as a woody plant with a tall trunk that usually grows to at least seventeen feet and has a single stem that can divide; a shrub is usually smaller, with many stems. The same species that matures into a tall tree in a fertile, temperate environment may be only a low shrub in a less hospitable location.

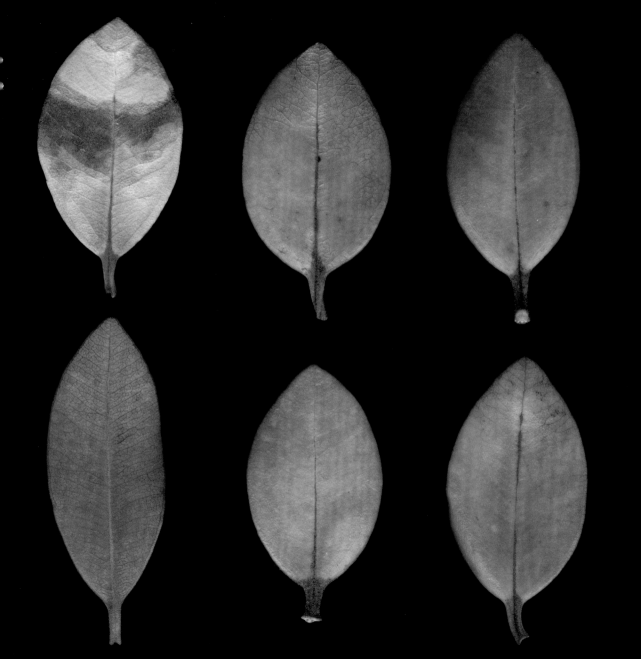

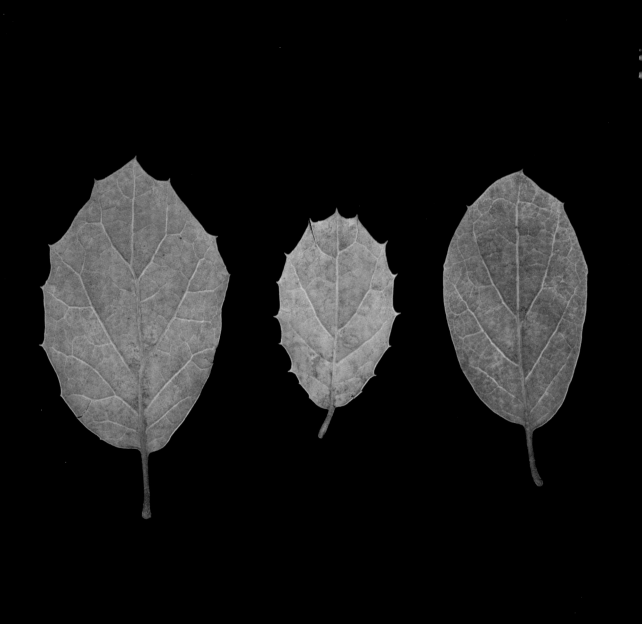

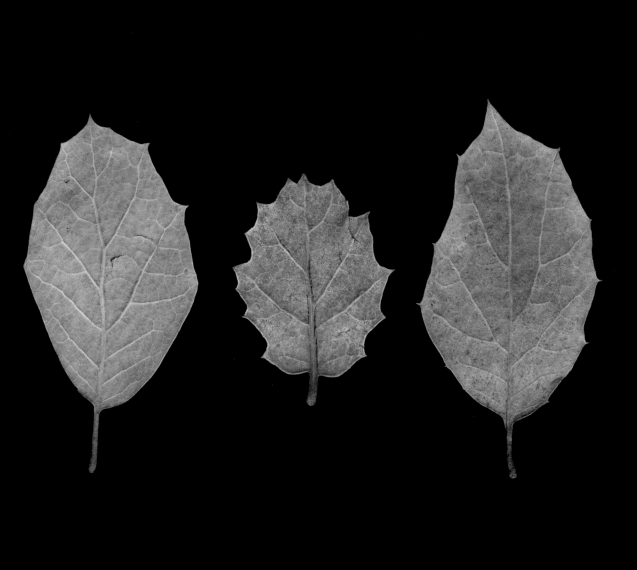

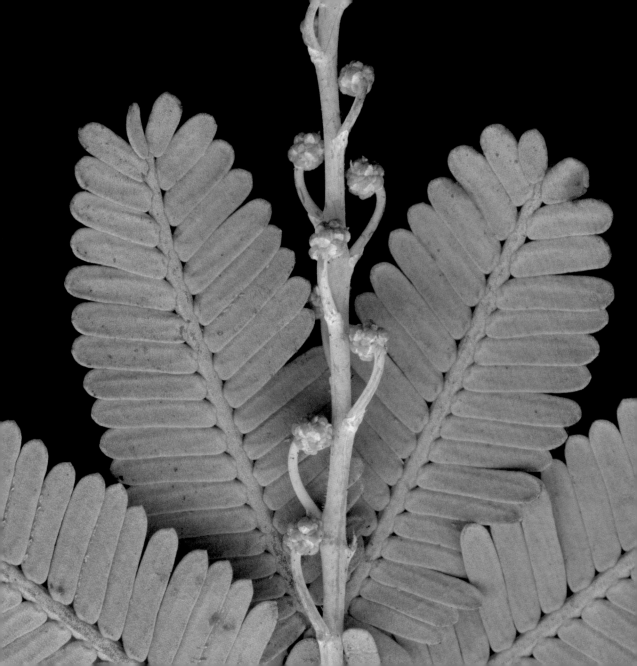

Preceding pages: **Coast live oak.** Leaf shape can be markedly dissimilar not only on the same tree but on the same branch, reflecting the leaves' varying ages, exposure to sun, and other environmental conditions. The coast live oak bears small, jagged-edged leaves and larger, smoother leaves; both are pictured. The smaller ones are the more mature leaves. Their spiky edges are better at conserving water and defending against predators; leaves near the bottom of a tree, within reach of grazing animals, often have them.

Opposite: **Bailey acacia.** The knobby stalks amid the acacia's feathery blue-green leaves will bloom into clusters of fragrant yellow flowers, which will give way to seedpods like the one on page 44. The pods are characteristic of trees that are members of the legume family.

Milkweed, acacia, and lunaria (money plant) pods. Pods protect the seeds within from being eaten, drying out, or germinating too early; they allow seeds to remain dormant until conditions for their growth are just right. Most trees produce their seeds in the fall, and delicate seeds would be making a big mistake if they decided to grow on a warm autumn day, only to freeze when the weather changes. The three pods here are all dry (not fleshy) and dehiscent—that is, they burst open at maturity to release their seeds.

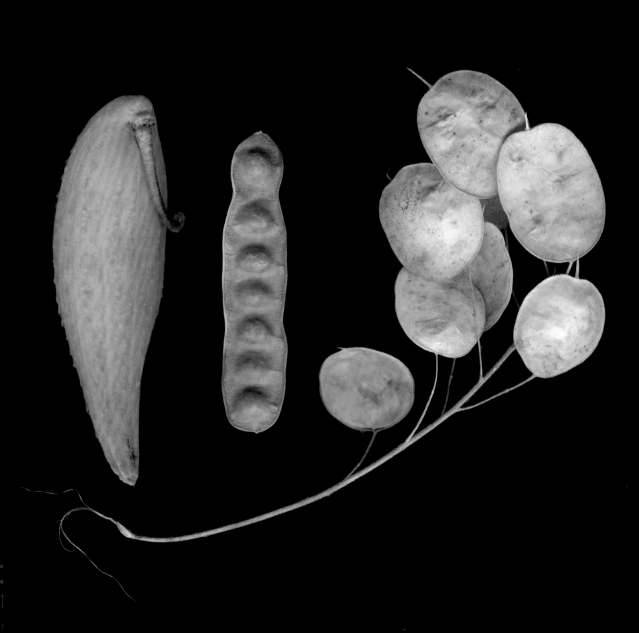

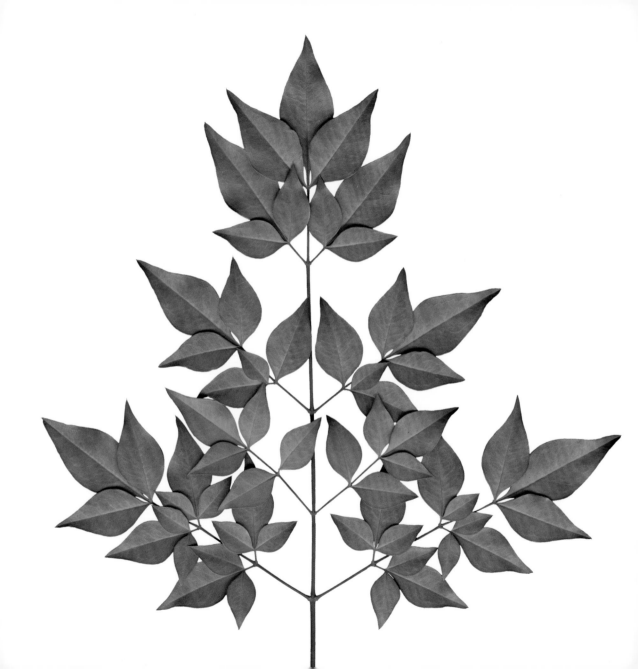

Heavenly bamboo. Compound leaflets like these allow wind to create turbulence as it passes over and around the tree, exposing the leaves to an ample supply of carbon dioxide. The many surfaces and edges of compound leaves also make it more difficult for insects to find footing. Native to central China and Japan, the heavenly bamboo is a member of the barberry family; despite its name, it is not related to bamboo, which is actually a grass. Its beautiful foliage transitions from pink in the spring to green as summer progresses and crimson in winter.

Rhododendrons. The young leaves of the rhododendron are poisonous, and honey from the flower's nectar reportedly incapacitated Greek soldiers in 400 B.C.; probably the plant had other predators in mind when it developed this defense. Rhododendrons have other defensive tactics, too; the leaves curl and bend to protect themselves against cold weather. Perhaps that's why the genus has survived so long and is so widespread. Fossil records put the rhododendron at one million years old, and its eight hundred species grow all over the world.

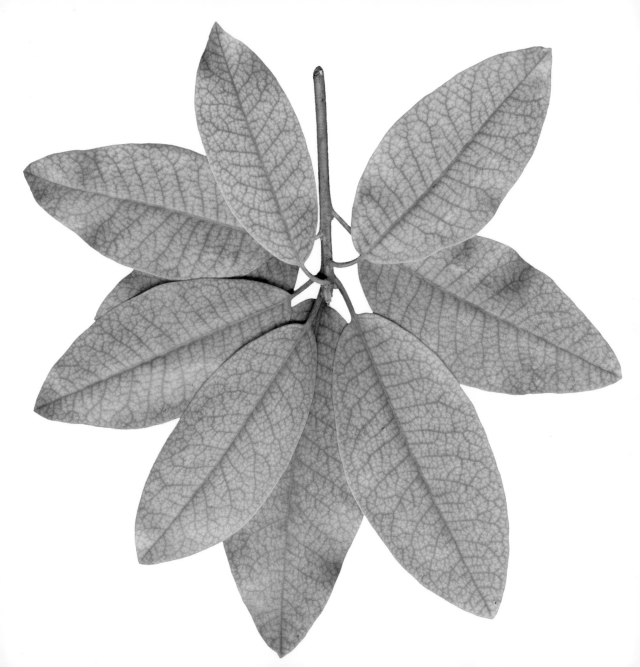

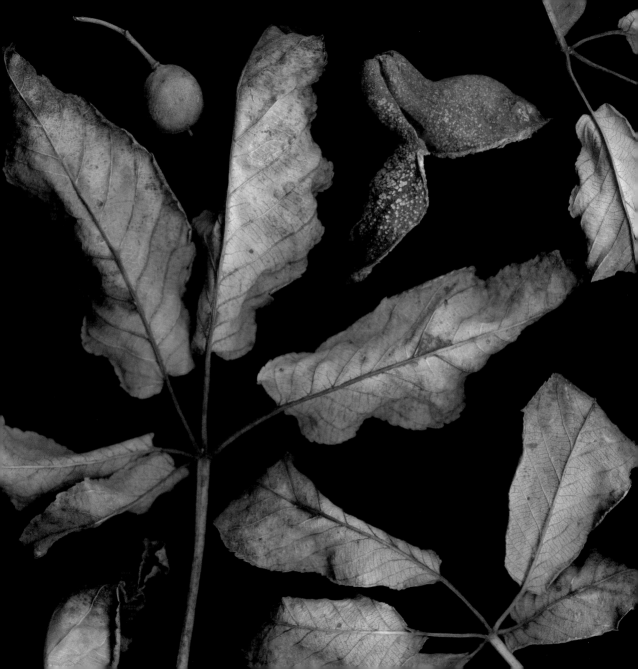

California buckeye. A member of the horse-chestnut family, it has distinctive, large leaves formed of five or seven leaflets that fan out or whorl from the stem. The nuts are inedible and considered toxic. Native Americans crushed them and added them to streams to stupefy fish, the easier to net them. Buckeye colonies are still found around historic Indian campsites.

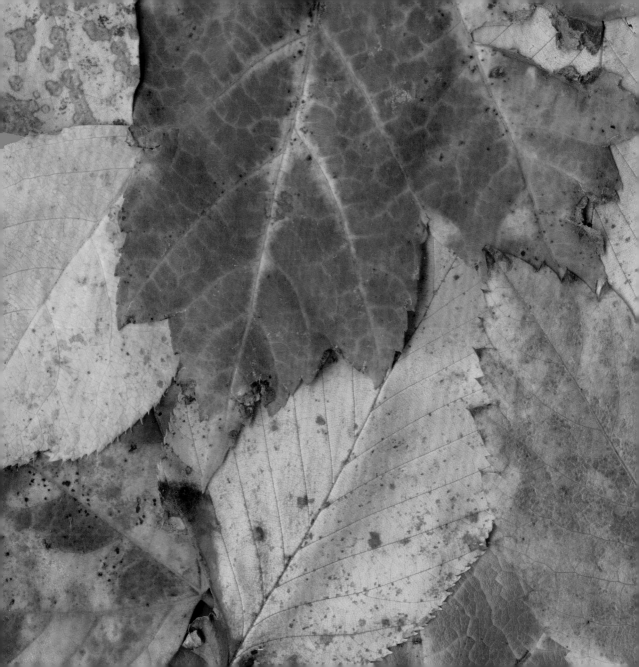

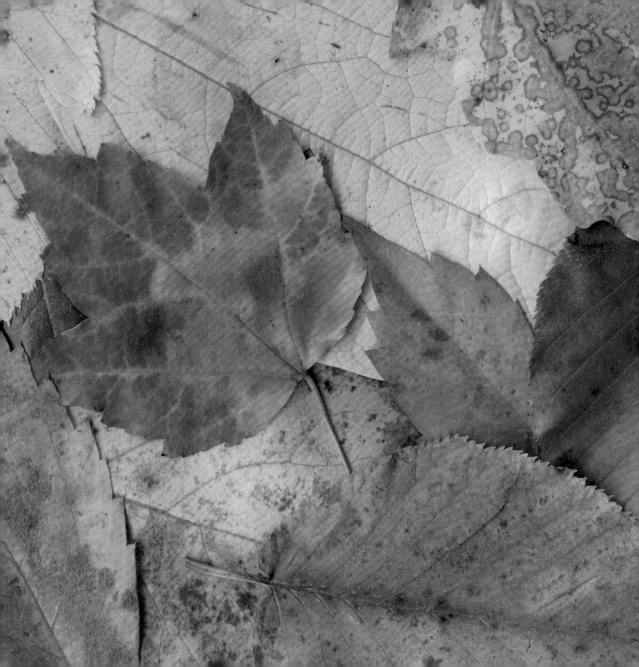

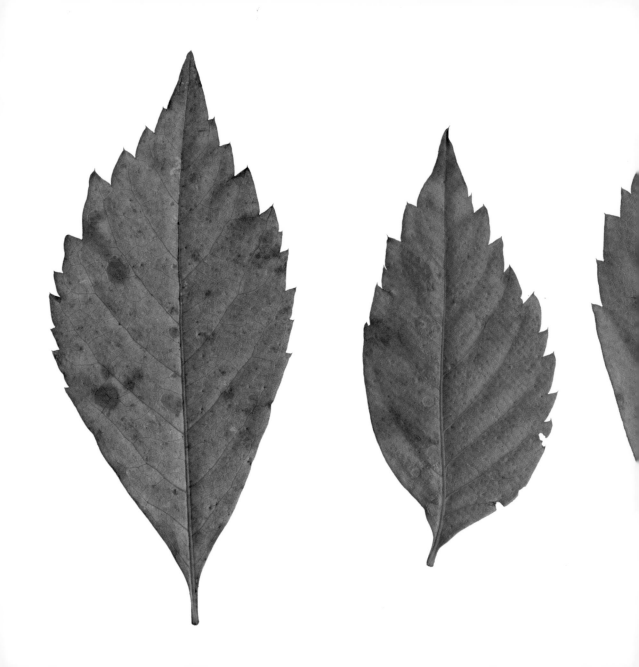

Preceding pages: **Beech and maple leaves from a forest floor.** *Opposite:* **Beech.** In autumn, as temperatures cool and sunlight dwindles, leaves finish their work of photosynthesis. At this time, most deciduous trees form a thin layer of cells between the leafstalk and the twig, sealing off the leaf to protect the tree from water loss. The leaf is eventually severed from the tree—leading to the fall that gives autumn its alternate name. On the forest floor, leaves offer a multilayered blanket that shelters hibernating animals and nourishes the soil as it decomposes. Fallen leaves also help trees aggressively protect their turf. Some are full of poisons that prevent the seedlings of competitive trees from gestating and growing there.

85

Maple. Brilliantly colored fall foliage depends on warm, bright days that stimulate photosynthesis and on chilly nights that prevent the resulting sugars from flowing back into the tree. Eventually the bright colors of Indian summer fade, and the mulching leaf turns brown. Moist, overcast autumns—like Keats's "seasons of mists and mellow fruitfulness"—typically result in brown, unspectacular displays.

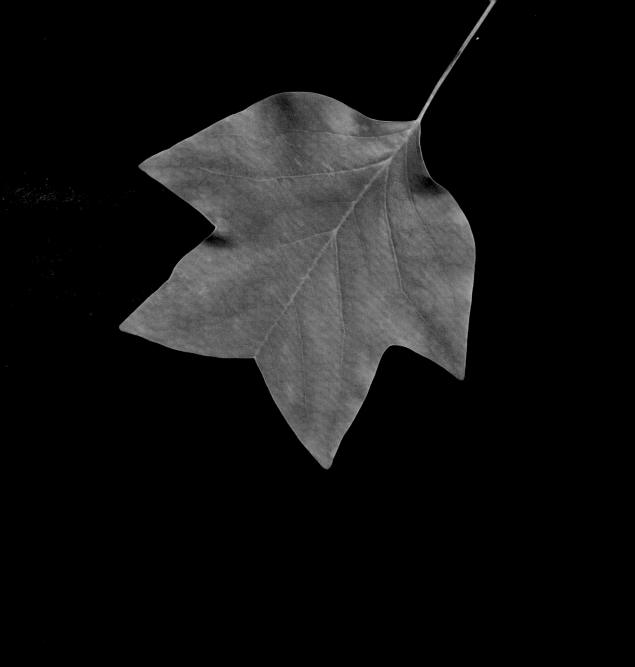

Tulip tree. The leaf of the tulip tree has a distinctive shape: Call it a bell, a saddle, or truncated, it is almost like a simplified, squared-off maple leaf. New tulip tree leaves have a wide yellow margin that becomes fully green as they mature. The tree's common name derives from the yellow tuliplike flowers it bears in the spring. It grows wild from Nova Scotia to Florida.

89

Damaged leaf. The tree is a marvel at cellular partitioning. Much the way it forms cellular dividing lines at the petiole when the time comes to let go of its leaves in the fall, it creates cellular boundaries around injuries to prevent damage from spreading. Thus a tree may sustain a deep cut to its trunk and keep growing around it. The same partitioning also helps leaves contain damage, like the fungal infection at the center of this one, protecting the whole leaf's photosynthesizing capacity from individual assaults.

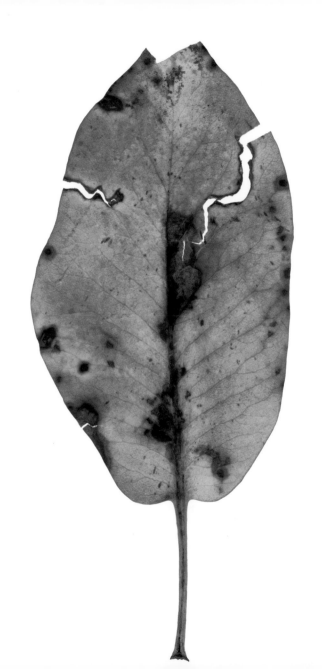

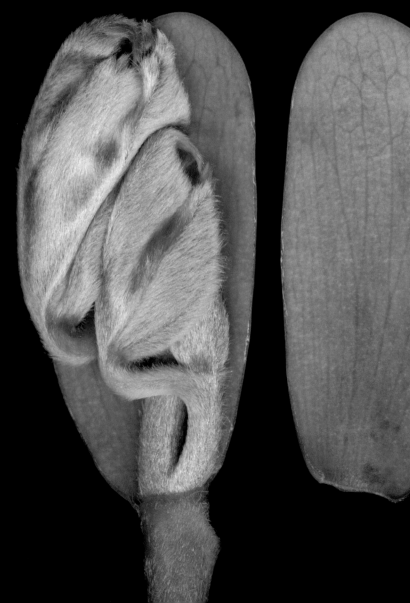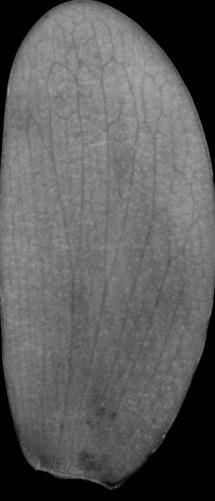

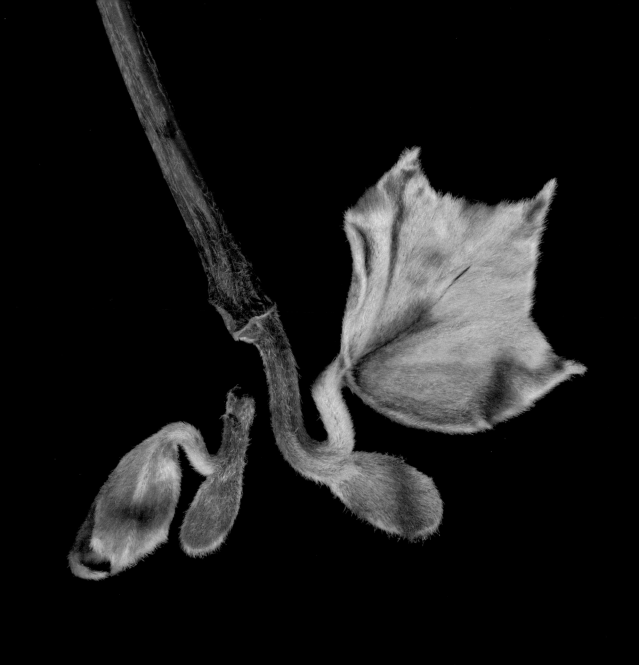

Preceding pages and opposite: **Exbucklandia poulanea bud and leaf.** What here looks like an abstraction of a flower and a tiny leaf is actually a mature leaf and a leaf bud. Embryonic leaves grow inside the scales of a bud (dissected on the previous pages), ready to emerge when springtime sap and the warming sun give them a jolt. The miniature version of the full-grown leaf quickly sheds its youthful fuzz and attains maturity. It is now ready to do the adult work of photosynthesis, building the tree's food supply instead of using it up for its own development. This tree and its triple-lobed leaf are found in Southeast Asian cloud forests— mountainous regions where temperatures are consistently cool, and vegetation is bathed in mist and fog.

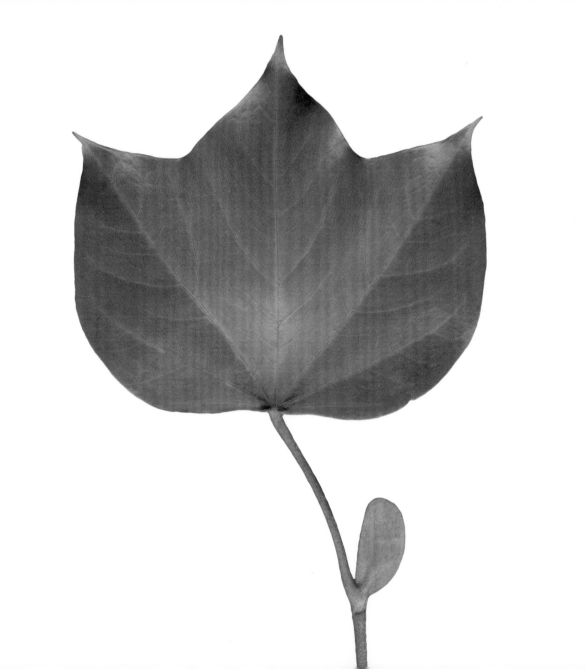

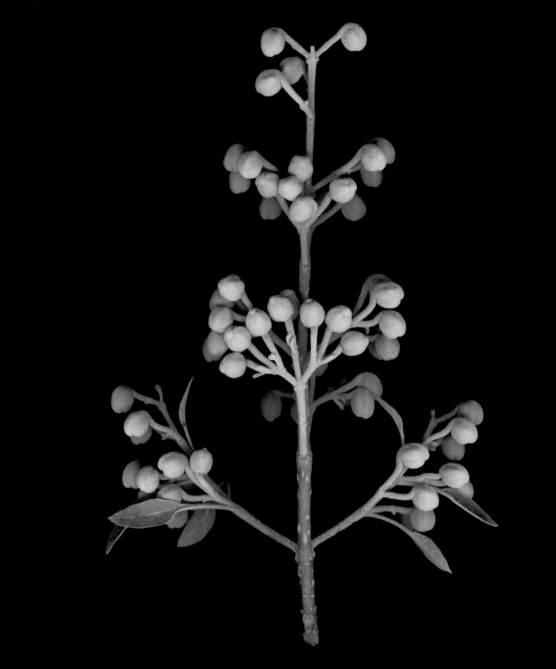

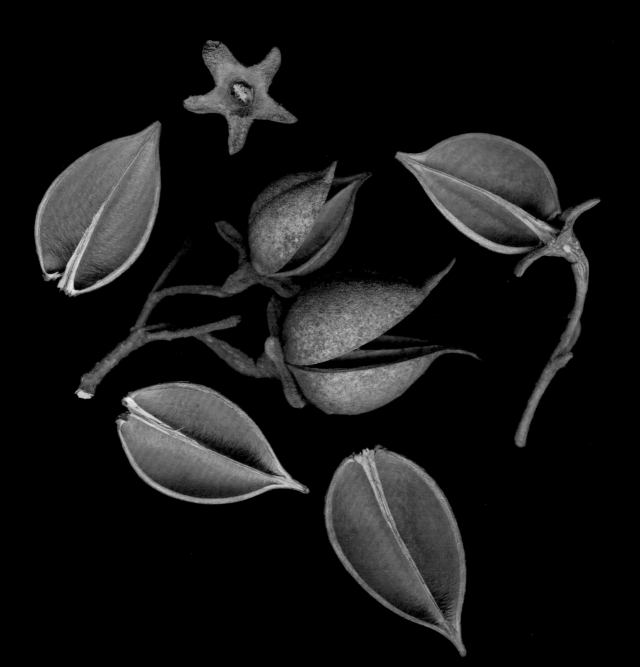

Preceding pages and opposite: **Empress tree flower buds, seedpods, and leaves.** Native to western and central China, the empress tree was cultivated both as an ornamental—it produces large lavender blossoms—and for its wood, which is fire-resistant. The flower buds form in upright clusters the summer before their blooming season and are often killed by frost over the winter. The dry brown seed capsules—each of which may contain thousands of winged seeds—clatter in the wind, lending another name to the tree: rattle box. The ten-inch leaves are thick, pointed, and fuzzy. The tree grows fast and lives long, an unusual combination.

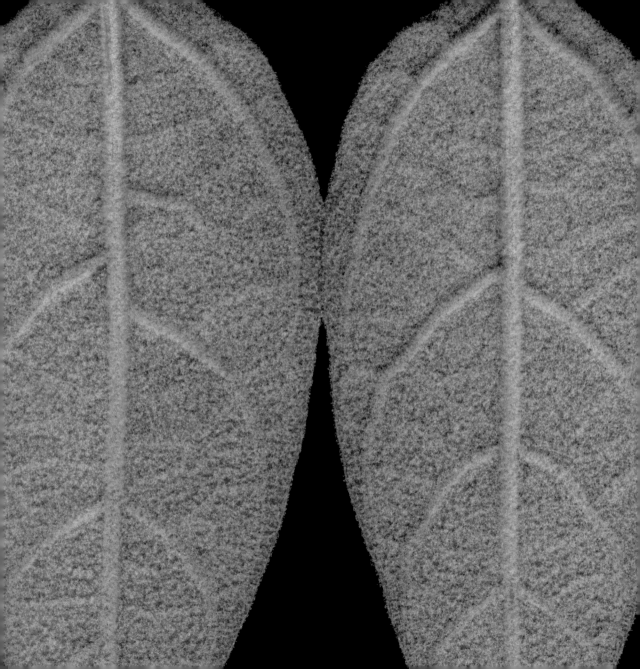

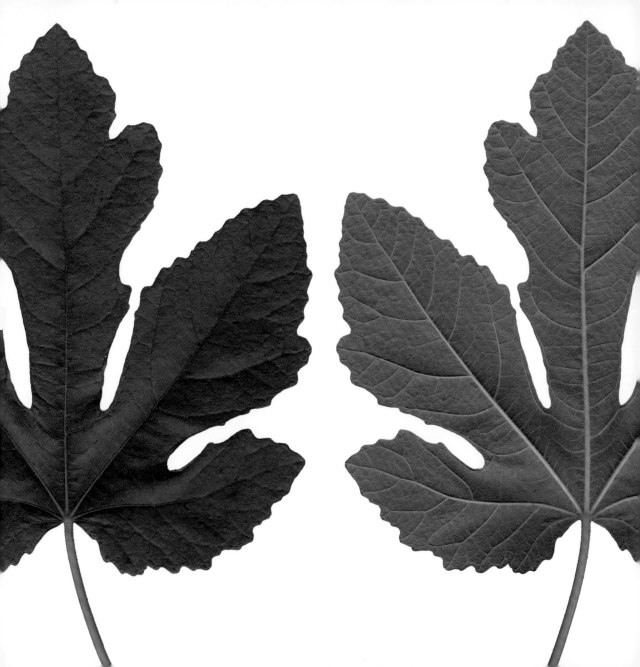

Fig. Many trees are venerated by cultures across the globe, but perhaps the most iconic is the fig. Romulus and Remus were suckled by their adoptive lupine mother under a fig tree, and Buddha attained enlightenment under another one. In the book of Genesis, sewn-together fig leaves covered Adam and Eve in their disgrace, testament to the leaf's leathery thickness and breadth. (Related species are not as deeply lobed as the examples here, providing more coverage.) Egyptian hieroglyphics praised figs as far back as 2400 B.C. Ancient societies likely held the fig in such esteem because it was a major source of sustenance. However, the edible part is not a single fruit, flower, or seed: It is a hollow case containing hundreds of flowers that mature into tiny, one-seeded fruits. The strawberry, with its multitude of seeds on the outside of the flesh, is the inverse.

Cockspur coral. The tree's demure flower buds, seen here, unfurl into showy, bright red flowers. In Argentina, where cockspur coral is the national flower, children call the bird-shaped blooms *patitos* (ducklings), because they float when set out on water. Native to rainy parts of South America, the tree has large, flat leaves good at capturing the available light without risk of water loss. Also called the "crybaby" tree, each of its leaves has a backward-hooking thorn capable of bringing tears to the eyes should you, or another predator, encounter it.

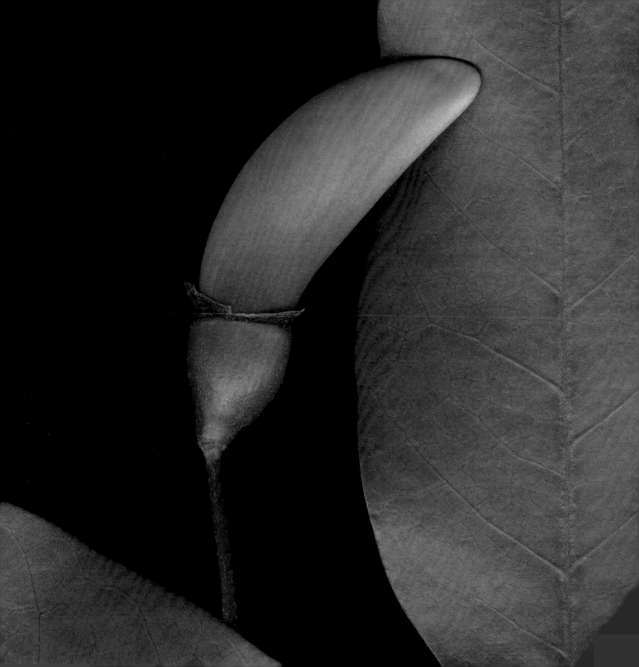

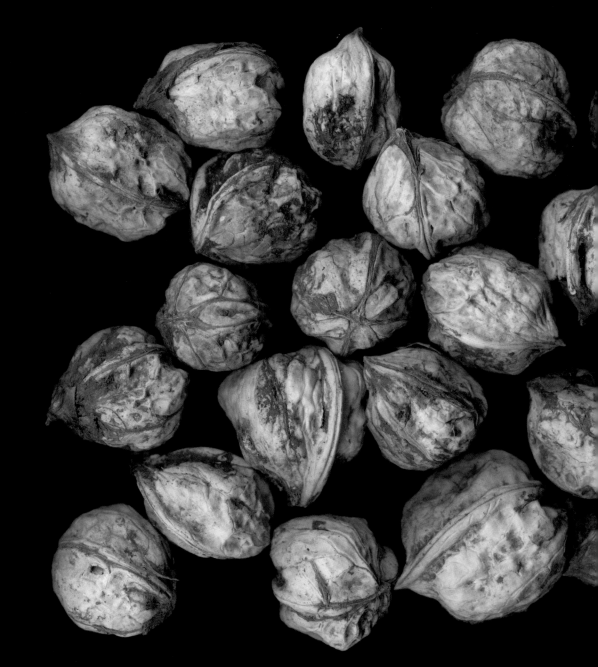

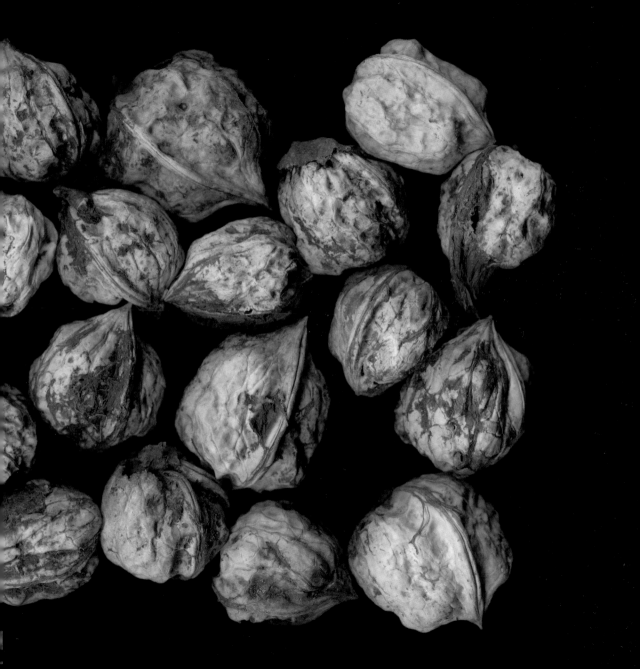

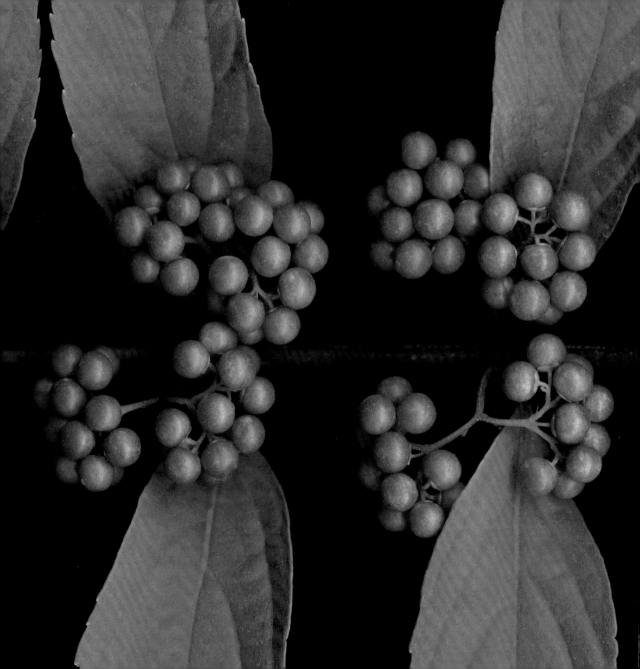

Preceding pages: **Walnuts.** *Opposite:* **Beautyberry.** *Following pages:* **Serviceberry, hawthorn.** The protective vessels in which any tree carries its seeds are its fruit. Sometimes we eat the fleshy seed casing—as with plums, apricots, and apples—and throw away the seeds. Other times we crack open the hard, dry casing and eat the seed, as with walnuts. Nuts are indehiscent, meaning that the casing does not split open on its own when the fruit matures; the seed is exposed only when the shell rots or is broken open by an animal. The flesh of fruits like berries not only protects seeds as they develop—many fruits are poisonous or astringent until ripe—but aids in their dispersal when the time comes. Birds and animals eat berries and then regurgitate, spit out, or excrete the seeds—optimally, far from their source, spreading a wide net of germination.

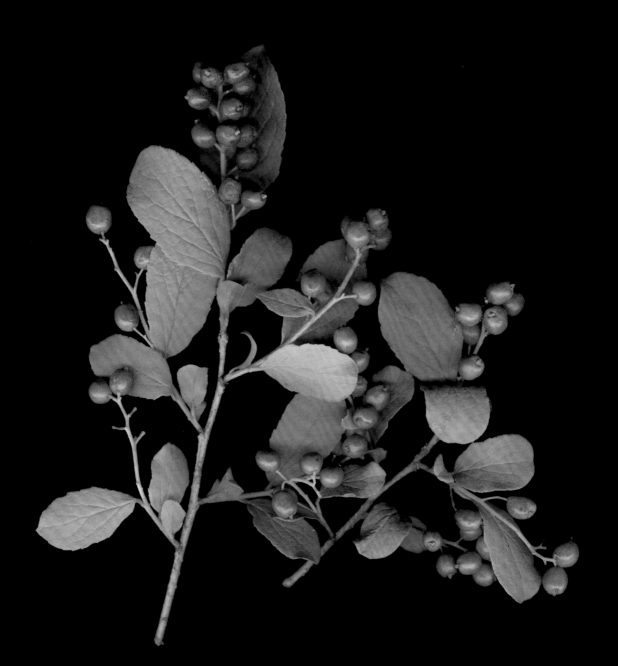

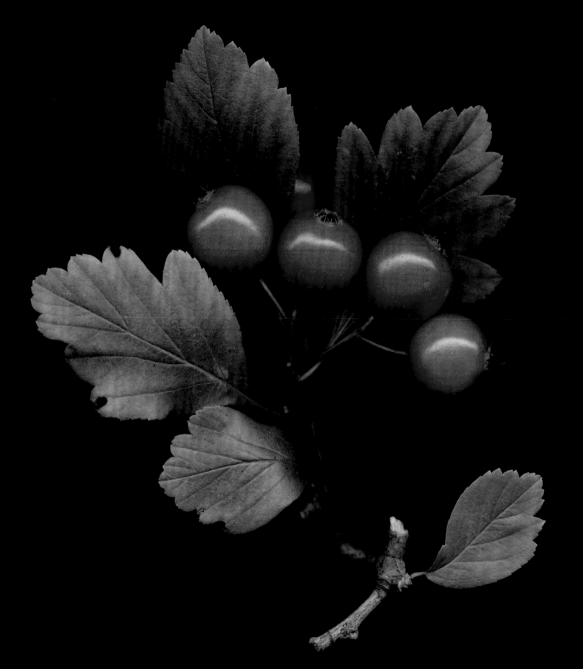

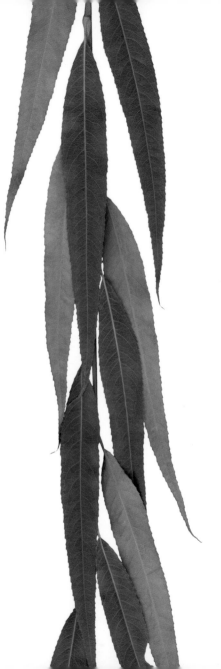

Weeping willow, curly willow. Weeping willows are synonymous with lazy afternoons with a book by a burbling stream; they habitually grow beside running water. The curly willow, an exotic-looking variant, doesn't grow naturally in the wild. Like other cultivars, it is likely the work of botanists and gardeners, who engineer new varieties to enhance the plant's performance or bring out its strange and beautiful qualities.

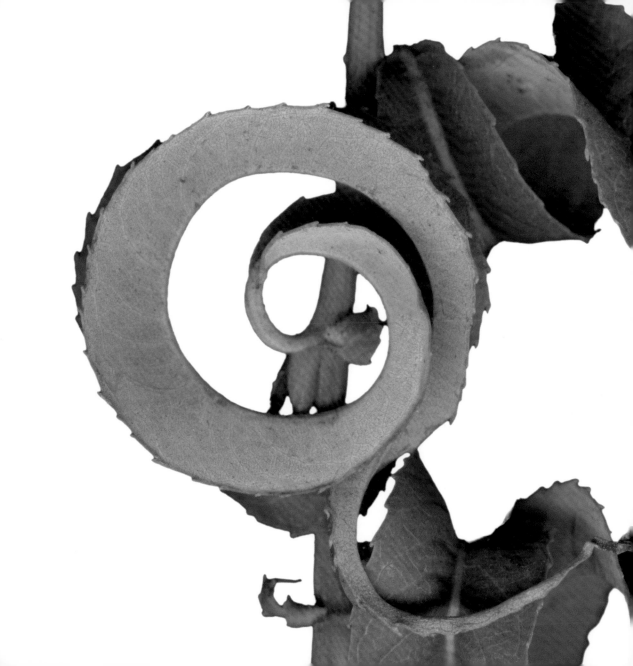

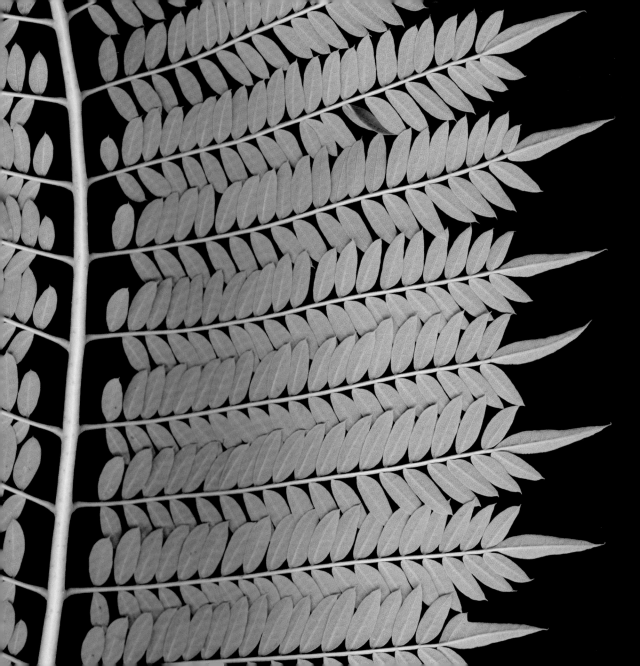

Jacaranda. This member of the trumpet vine family is highly ornamental. Its bright green fernlike leaves, each comprising twelve or more pairs of leaflets, can be up to twenty inches long. The tree blooms abundantly with lilac blue flowers, which are followed by leathery, disklike pods containing numerous winged seeds.

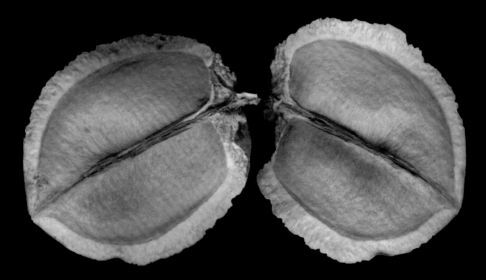

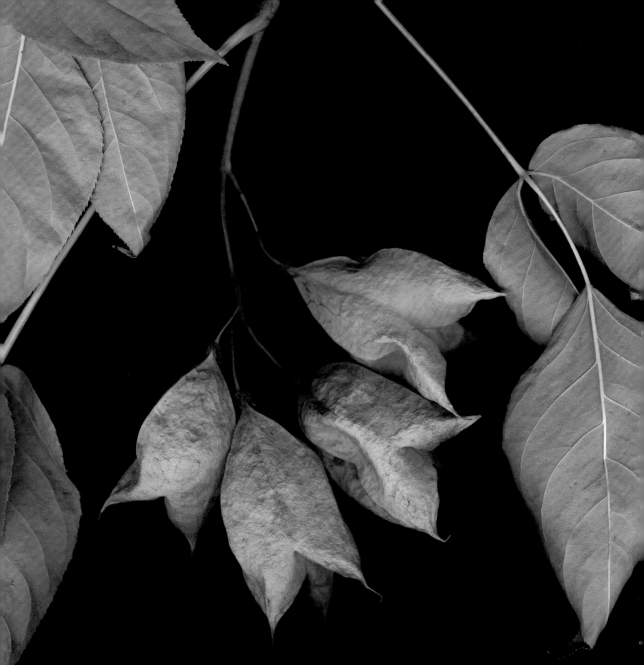

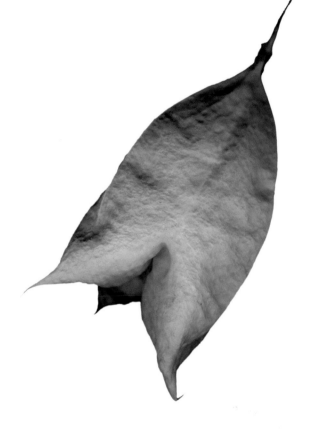

Bladder nut. The lantern-shaped pod of the bladder nut holds its seeds like a rattle. The nearly identical shape of the pod to the leaf is pure camouflage, tricking predators who are looking for nourishing seeds. Insects and animals develop search images—for example, the shape of a cone—that they pursue for food. The bladder nut has adapted cleverly to deceive them.

Opposite: **Plum, pear, and plum.** *Following pages:* **Persimmon.** Trees could never produce the fruit we eat without the food-manufacturing efforts of their leaves. An apple is the product of at least fifty leaves' work making sugar and carbohydrates; a bunch of bananas results from the output of a few enormous banana leaves. The delicate-looking leaves here do the same vital work. The serrated plum and the leathery pear leaves turn yellow in the fall, while the persimmon leaves on the next pages blaze a coppery pink.

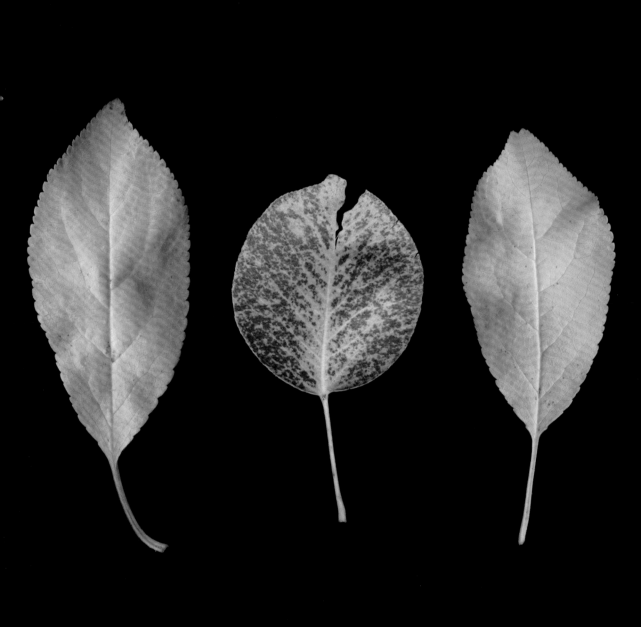

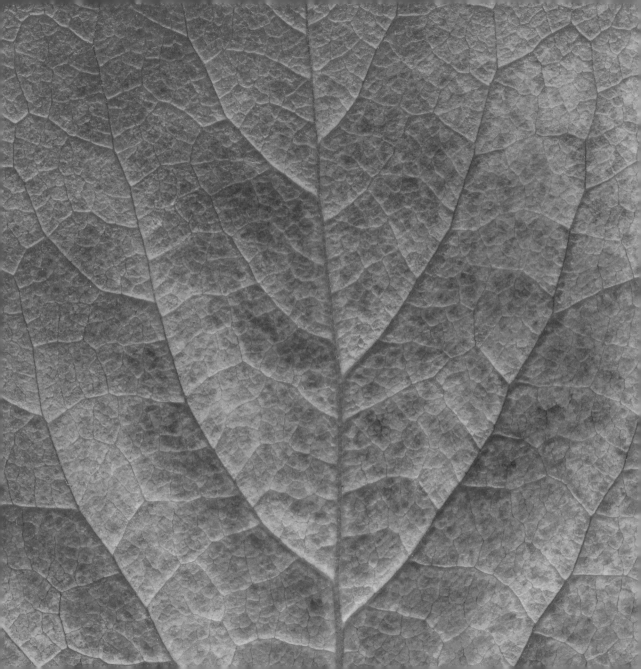

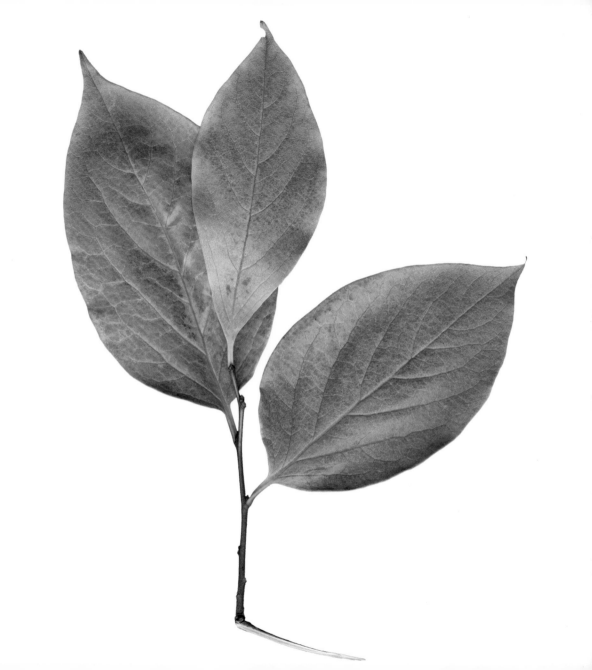

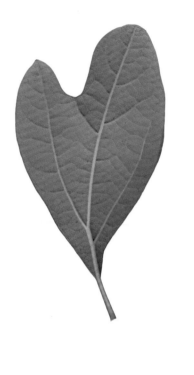
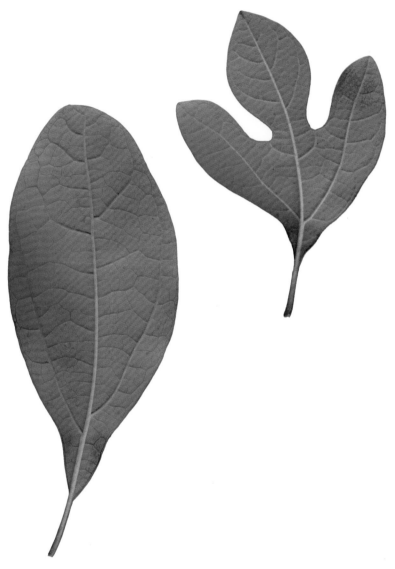

Sassafras. The sassafras is unique in that a single tree produces three distinctly shaped leaves—sometimes on the same twig. They may be unlobed, double-lobed and mittenlike, or triple-lobed (trident), but they always have three major veins stemming from the base. The aromatic root bark was originally used to make sassafras tea and root beer.

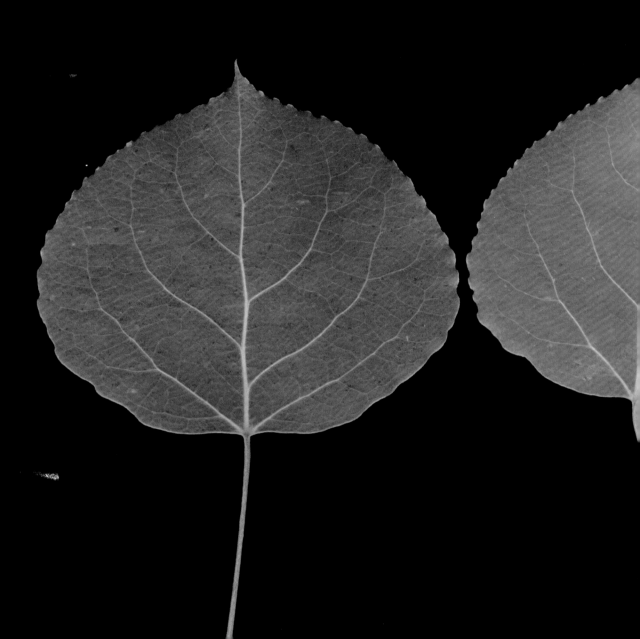

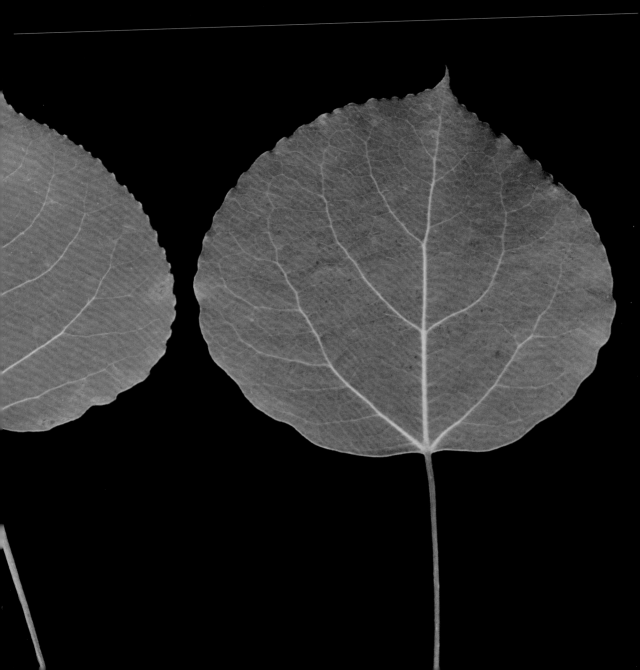

Preceding pages and opposite: **Aspens.** Commonly known as quaking aspens, their thin, rounded leaves on delicate stalks move with the slightest breeze, making the branches seem to dance with shimmering quarters. The fluttering serves a purpose: Keeping each leaf at a right angle to the wind minimizes its surface exposure and thus protects the leaf from dehydration.

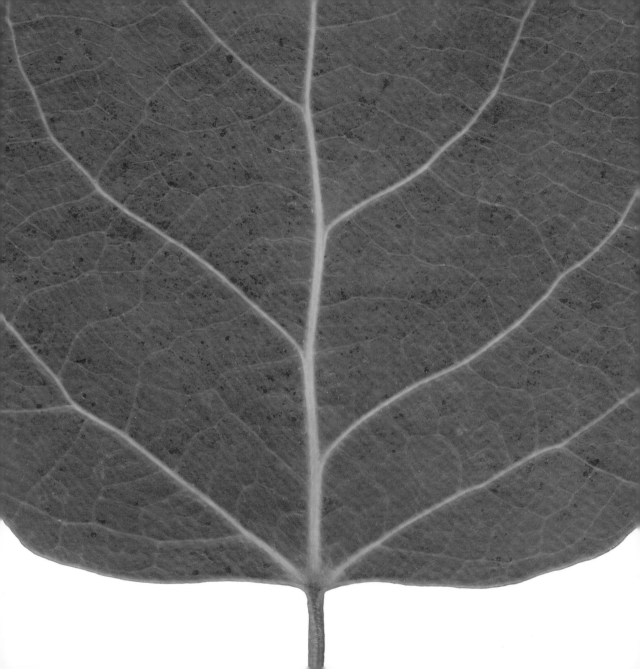

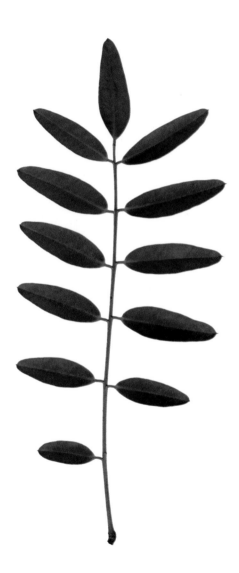

Pagoda leaf and pods. Also called the Japanese scholar tree, it is a member of the legume or pea family, which includes the acacia and locust. Its characteristic pods are constricted between each seed, like a string of beads. Legumes are dehiscent; at maturity, the pod splits open into two halves, revealing seeds side by side. The pagoda's leaves don't turn color in autumn, but the green pods—which can be eight inches long and contain up to six seeds—turn yellow and then brown.

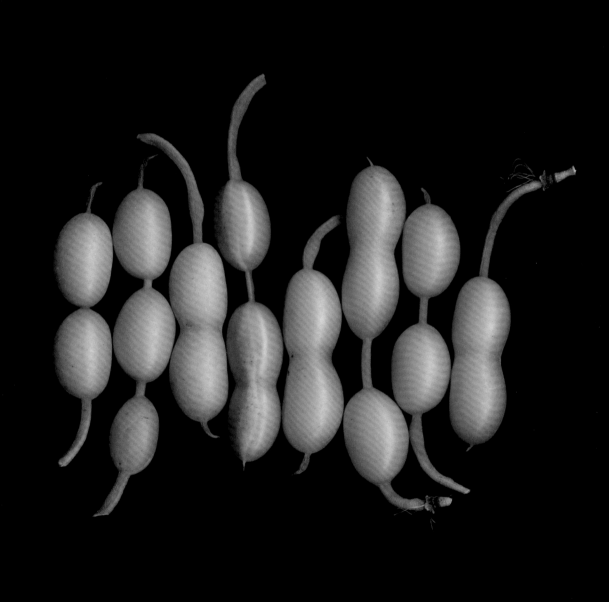

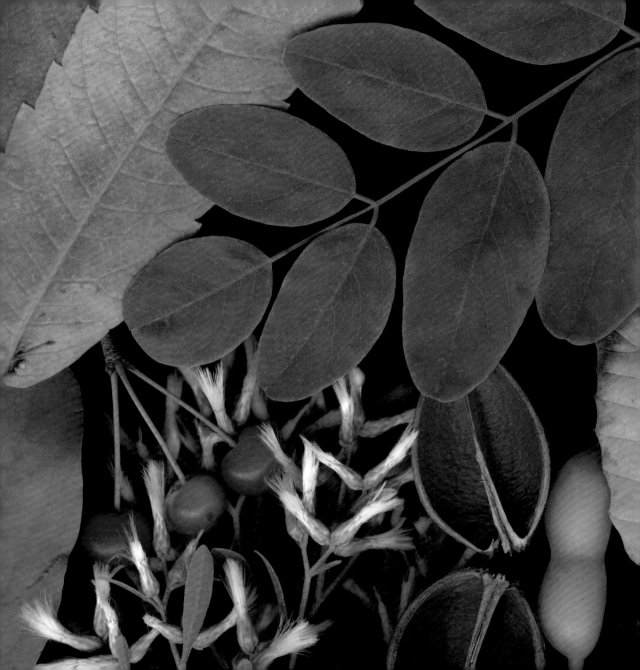

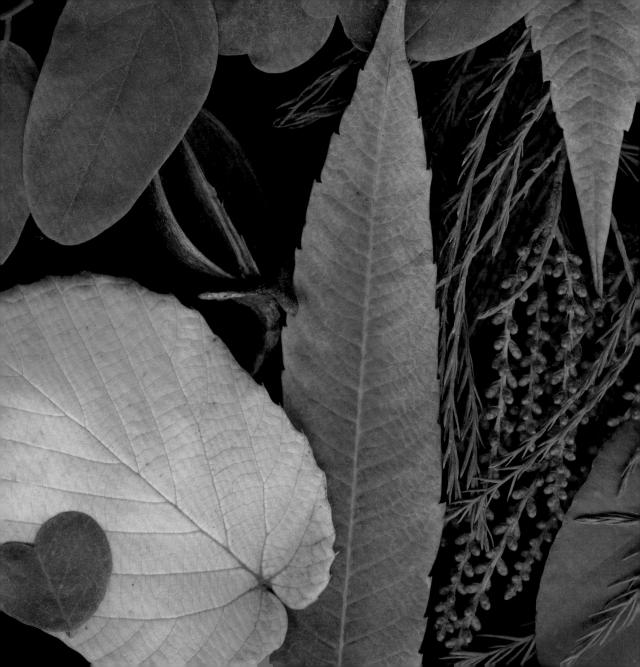

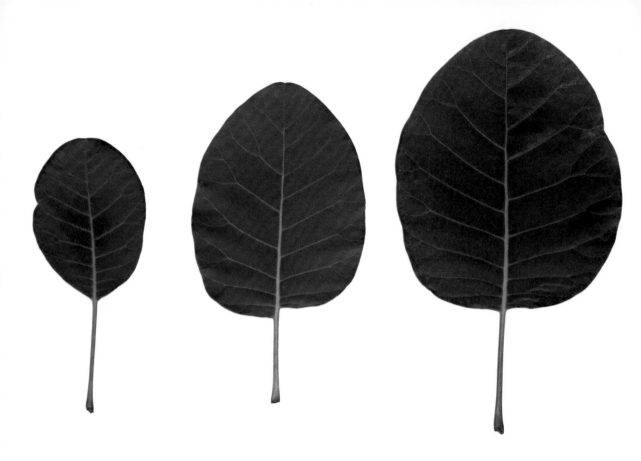

Smoke tree. This tree's leaves are green on top and purple-hued underneath; both sides of three leaves are shown here. The two-sided coloration developed in this cultivar is uncharacteristic of the typical smoke tree but common to many other species. Leaves with very short or firm stems that don't move much usually

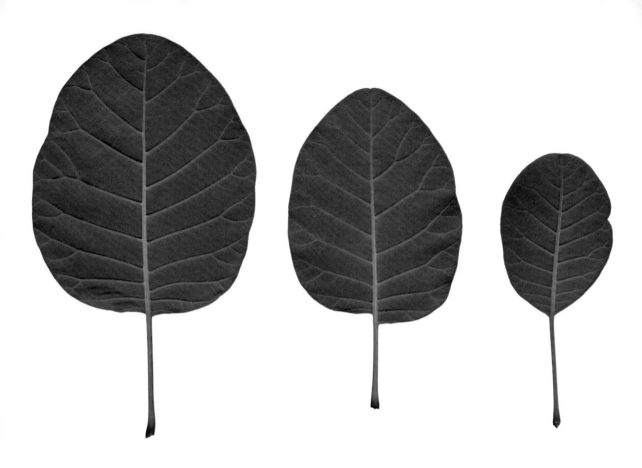

have differently colored surfaces to accommodate the varying degrees of sun and shade either side receives. Magnolia leaves, for example, have tobacco-colored, feltlike undersides and are a glossy dark green on top. By contrast, the aspen, which trembles in the lightest wind, is almost identical on either side.

Leatherleaf viburnum. The primary and secondary vein patterns on this tough viburnum are almost equally emphatic, as if the so-called leatherleaf were actually tooled. Part of the woodbine family, the viburnum's hundred species grow in the temperate regions of the northern hemisphere; they are cultivated for their pretty flowers.

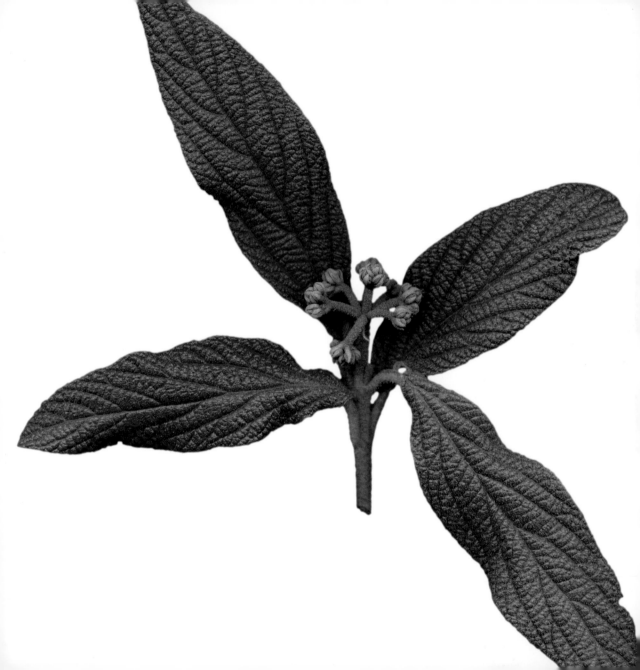

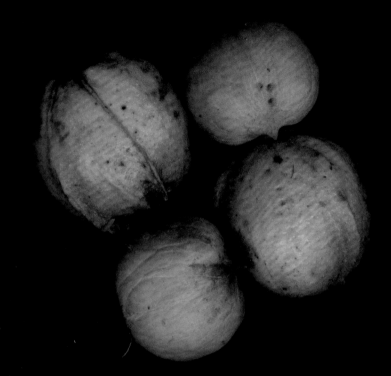

Above: **Hickory nuts.** *Opposite:* **Chestnuts.** Nuts are one-seeded fruit whose very hard shell, the pericarp, is actually the wall of the fruit or ovary. They are usually encased in a husk, like the green layer seen on these hickory nuts, or a covering called an involucre. The chestnut's involucre (not shown here) is made of spiky spines; the acorn's is a cap of overlapping scales. Nuts have a high oil content that provides long-lasting nutrition for animals storing up against the ravages of winter.

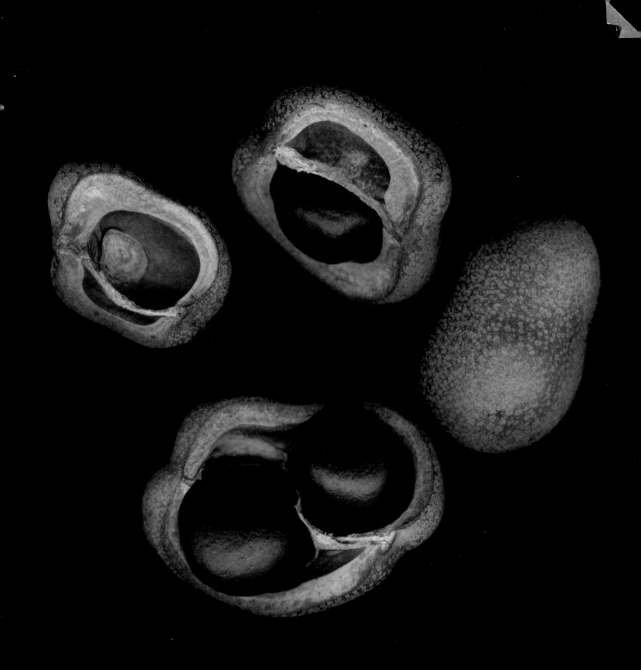

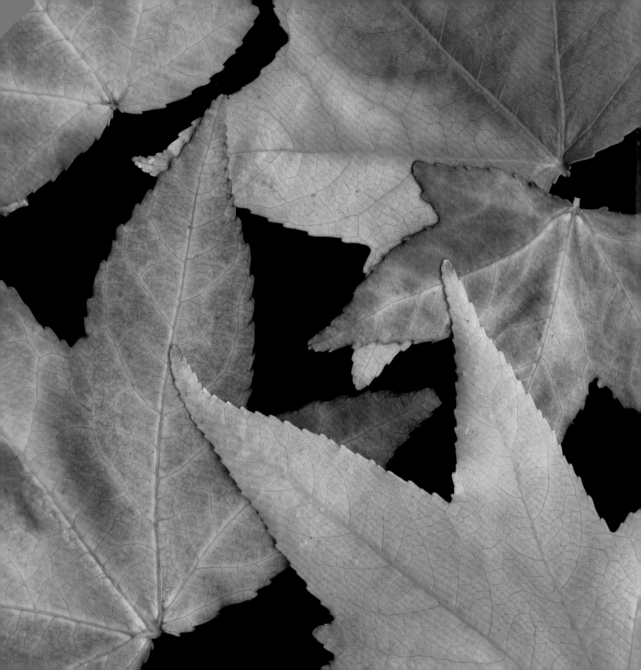

Sweet gum. Most leaves are green as they mature because they are full of green-pigmented chlorophyll, which absorbs much of the red and blue parts of the visible spectrum, leaving green to radiate back. As leaves slow their production of chlorophyll in the fall, other pigments are revealed: the orange carotenoid, yellow xanthophyll, and red anthocyanin, which, together with remnants of chlorophyll, produce the array of autumn colors. The sweet gum's star-shaped foliage takes on a rich palette, including purple, crimson, and orange, even in mild climates and when the season is warm. Also known as liquidamber, the tree's names refer to its aromatic resin, which may have been the balm used in Gilead.

Olive. The olive tree thrives in a mediterranean climate—with dry, hot summers and mild, wet winters—and on craggy limestone hills. An important source of fruit, oil, and fine wood for thousands of years, the olive is a symbol of prosperity as well as peace. The latter attribute may stem from the once long interval between planting the tree and harvesting its fruit: Cultivating olives required patience, but the result was worth the wait. As Thomas Jefferson said, "The olive tree is surely the richest gift of heaven."

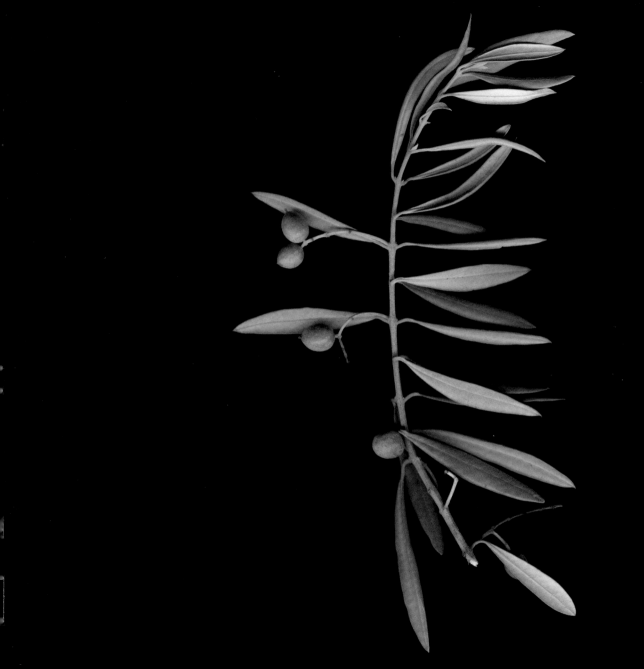

artist's note

As every photographer knows, the ordinary is anything but. For years I have mined my household for everyday things and used my flatbed scanner to examine them: dryer lint, vegetables, balls of yarn, even the collections of stones piled around the house, which gave rise to the first book in this series, *Beach Stones*. When I found a perfect skeleton of a lemon leaf in my backyard compost bin and saw how the scanner captured all its delicate, decomposing glory, I was inspired to venture into the neighborhood and to the botanical garden to look at leaves and pods.

The first leaf images to emerge from the scanner onto my computer screen startled me with the intensity of their color and form. After working for months with the subtle variations and muted hues of softly silhouetted beach stones, I was delighted by the sharp visual detail each leaf provided: the distinct shapes; the intricacies of the vein systems; the range of brilliant, saturated color; the crisply smooth or spiny edges. Learning how those attributes serve to sustain both the tree and life on our planet has been thrilling.

My use of a scanner instead of a camera is well suited to exploring forms in nature such as leaves and pods. The focus of scanner photography is strictly

on the object, and it allows for a fantastic clarity as I zoom in closer and closer. It follows in the tradition of Karl Blossfeldt, who built his own large-format camera in 1896 to make stupendously graphic images of plants, and expands on the concept of the photogram, an image made by setting an object directly on the exposing photopaper.

The scanner's flat glass surface is a fluid conduit for rendering three-dimensional objects into two-dimensional artwork and lets me design quickly. Timing is important: I had only hours—or at most a day or two—before the leaves began to deteriorate. I also devised a traveling studio with my laptop and scanner to capture my subjects on the road.

Although each detail of leaf and pod seems, on close examination, like an exotic revelation, most of the ones shown here are relatively common. They come from the trees in my San Francisco neighborhood or in friends' backyards, from Boggy Meadow Farm in New Hampshire (thank you, Lovell-Smiths) and from Sky Farm in Maine (thank you, Lamonts). Many come from two fantastic horticultural realms, the San Francisco Botanical Garden and the Brooklyn Botanic Garden.

This project has been a collaboration with Mary Ellen Hannibal and many others. I must thank Jackie Fazio and Leeanne Lavin at the Brooklyn Botanic Garden for guiding me through their collection. I also thank Eric Himmel, editor in chief of Abrams, for setting me on this exploration of forms in nature; Caroline Herter of Herter Studio for connecting us; Kate Stickley for numerous plant identifications; Cathy Iselin, a constant inspiration and help; and Mike Sullivan for writing a wonderful book, *The Trees of San Francisco*, that led me to the most interesting trees in my hometown. The Abrams team—Darilyn Carnes, Nancy Cohen, and Jane Searle—is a privilege to work with. Last, I thank my husband, Ken Pearce, and my three children, Eliza, Deedee, and Andrew. Their delight in my projects inspires me, and their advice almost always results in something better.

JLI

writer's note

Something is in bloom at every time of the year in San Francisco, where I live. Nearly any kind of plant can and does grow here, due to California's mediterranean climate and the city's unique situation amid hills and on the bay. Many of the leaves in this book, though native to other habitats, came from the San Francisco Botanical Garden. A living museum, it is maintained by city employees and volunteers with a great passion for nature, and my understanding of leaves would be far less without their hard work.

In particular I would like to thank the botanical garden's Don Mahoney, horticultural manager, and Tony Morosco, plant collections manager, for the generous time spent with me poring over the words and pictures of this book. I would also like to heartily thank Eric Himmel and Nancy Cohen for their beneficent editing styles and, especially, Josie Iselin for her razor-sharp appreciation of natural forms and her ability to render them so beautifully.

MEH

143

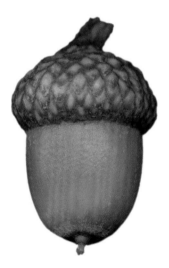

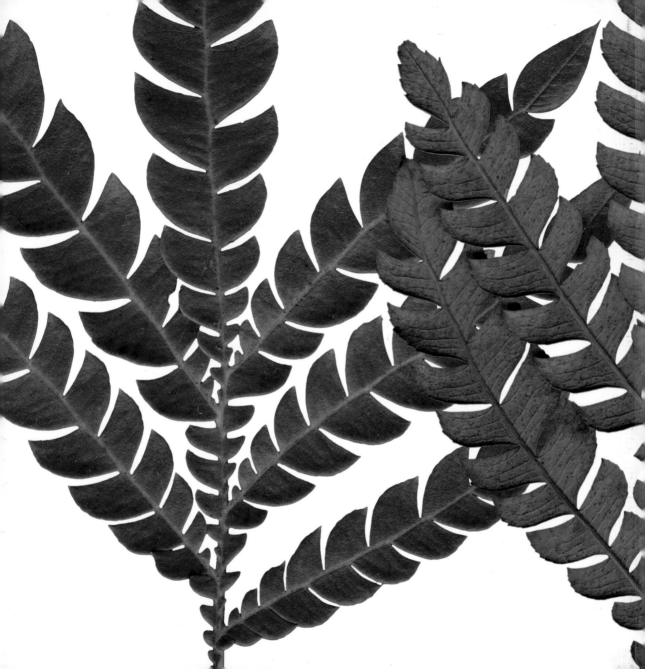